IMAGES
of America

THE LONG ISLAND
MOTOR PARKWAY

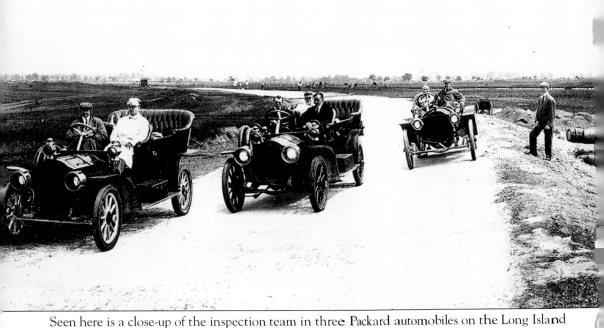

Seen here is a close-up of the inspection team in three Packard automobiles on the Long Island Motor Parkway prior to its opening in October 1908. This photograph was taken with a two-fold purpose. One was to highlight the width of the roadway and its passing capabilities, and the other was to show the banking of the road surface through the curved section, both features critical to the upcoming Vanderbilt Cup Race. (Courtesy of the Garden City Archives.)

On the cover: In western Nassau County, halfway between the hilly north shore and the ocean, are the Hempstead Plains of Long Island. This photograph was taken in September 1908 from the Carman Avenue Bridge at East Meadow looking west. The higher elevation of the bridge built by the Long Island Motor Parkway allowed the photographer an opportunity not previously available, to capture the flatness and expanse of the plains. Having bisected the plains, the Long Island Motor Parkway over the next 100 years would play an important role in the development of this part of Long Island. (Courtesy of the Garden City Archives.)

IMAGES
of America

THE LONG ISLAND
MOTOR PARKWAY

Howard Kroplick and Al Velocci

ARCADIA
PUBLISHING

Published by Arcadia Publishing
Charleston SC, Chicago IL, Portsmouth NH, San Francisco CA

Printed in the United States of America

Library of Congress Catalog Card Number: 2008923564

For all general information contact Arcadia Publishing at:
Telephone 843-853-2070
Fax 843-853-0044
E-mail sales@arcadiapublishing.com
For customer service and orders:
Toll-Free 1-888-313-2665

Visit us on the Internet at www.arcadiapublishing.com

This book is dedicated to our wonderful wives, Roz Kroplick and Louise Velocci, in appreciation of their love, understanding, support, and patience.

CONTENTS

ACKNOWLEDGMENTS

We would like to thank the many people and organizations that made contributions to this book: Helene Abramowitz, Sam Berliner, Brown Brothers, Cradle of Aviation Museum, John Cuocco, the Lester Cutting family, Garden City Archives, George Eastman House, Robert Harrington, Jerry and Linda Helck, the Historical Society of the Westburys, Mitch Kaften, Joyce Kalleberg, Roz Kroplick, Virginia MacMurray, Walter McCarthy, the National Automotive History Collection at the Detroit Public Library, the New-York Historical Society, Florence Ogg, Karyn Reinert, Ron Ridolph, the Richard H. Handley Collection of Long Island Americana at the Smithtown Library, Tom Saltzman, Joshua Stoff, the Suffolk County Vanderbilt Museum, Town of Hempstead Archives, UCLA Department of Geography, Bob Valentine, Louise Velocci, Margaret and George Vitale of Lake Grove, New York, Westbury Memorial Public Library, Dale Welsch, and Maryann Zakshevsky. Unless otherwise noted, images are from the collections of Howard Kroplick or Al Velocci.

Special recognition is due Cathy Ball, Long Island Room librarian of the Smithtown Library; Stephanie Gress, director of curatorial affairs of the Suffolk County Vanderbilt Museum; and John Ellis Kordes, Garden City historian and responsible for the Garden City Archives. Their knowledge and support of this project are greatly appreciated.

INTRODUCTION

Unlike the first roads built for commerce and horses, the Long Island Motor Parkway was conceived from a sporting contest—the colorful, exciting, and often dangerous Vanderbilt Cup Races. At the beginning of the 20th century, the superiority of European automotive craftsmanship cast a long shadow over America's fledgling car industry. To encourage American automobile manufacturers to challenge European quality, 26-year-old William K. Vanderbilt Jr., heir to a railroad fortune and a pioneer race car driver, sponsored America's first international road race modeled after those in Europe. The first William K. Vanderbilt Cup race was held in 1904 over 30 miles of public roads in central Long Island. By 1906, fans from all over the country swarmed to Long Island to witness the battle of automobiles from the United States, France, Germany, and Italy. Some of the reckless among the 250,000 spectators surged onto the narrow dirt roads to view their favorite drivers. The luck of the crowd ran out during the 1906 race when a spectator was fatally struck by a race car.

The death of a spectator nearly brought the classic to a premature demise. The marvel was that only one spectator had been killed in the three races held up to that time. Demonstrating vision again, Vanderbilt chartered the goal of a private highway. His dream was for a safe, smooth, police-free road without speed limits and a place to conduct his beloved international race without spectators running onto the course. Vanderbilt and his associates were careful to position this new and modern Appian Highway as a modern convenience to all automobile enthusiasts and not primarily as a speedway for race cars. They extolled the virtues of economic development and the efficiency of quickly retreating from the city to the calm and healthful benefits the fresh country air that Long Island had to offer.

On December 3, 1906, the Long Island Motor Parkway, Inc., was incorporated with Vanderbilt as president. The other officers were Harry Payne Whitney (vice president) and Jefferson De Mont Thompson (treasurer). Nominated as second vice president and eventually general manager was his good friend A. R. Pardington. Other notable directors and incorporators included Henry Ford, August Belmont, Frederick Bourne, Mortimer Schiff, John Jacob Astor, and Clarence Mackay. At the annual Automobile Club of America (ACA) banquet held five days later, Vanderbilt voiced his goals with the parkway:

> It has been the dream of every motorist to own a perfect car and to have a road without speed limit . . . There is to be constructed a private right of way through the center of Long Island in an easterly direction from the city limits, a highway to be built on a 100 foot right of way and having an approximate width of 50 feet. Grade crossings for both railways and highways are to be eliminated by the construction of bridges and tunnels and the entire

distance to be fenced. Access and egress to this boulevard will be obtained at toll gates erected at intervals of about five miles. The surface of the road will be either oiled or tarred and maintained in first class order so that the motorist can enjoy a ride without dust, without bumps, and last, but not least, have no interference from the authorities . . . If we can prove to the public it is a paying investment we will not only have the Long Island Motor Parkway but roads of a similar character extending to Philadelphia, Albany, Boston, and many other smaller towns.

A frustrating series of setbacks in obtaining rights-of-way to privately owned property resulted in a steady series of missed project milestones. The Vanderbilt Cup Race Commission was eventually forced to cancel the 1907 race, and construction of the parkway was delayed until 1908.

Throughout 1907 and the first half of 1908, A. R. Pardington, the parkway's general manager, worked hard to successfully obtain the right-of-way from Queens to Lake Ronkonkoma. On June 6, 1908, the parkway staged an official groundbreaking ceremony to commemorate the beginning of construction in Central Park, now Bethpage. With several hundred people in attendance, the original plan was for Vanderbilt to make the keynote speech. But the sudden and grave illness of his stepfather, Oliver Hazard Perry Belmont, kept him away.

Pardington, filling in, read from remarks Vanderbilt had written to mark the occasion. His comments praised the impact and potential of the automobile and reflected on the unforeseen obstacles that impeded the parkway's progress. Construction of the parkway began between Westbury and Bethpage with a little more than 9 miles of the planned 50-mile road completed in 1908.

The most distinctive features of the parkway were the reinforced concrete pavement and the elimination of grade crossings. Another innovation was the banked curves, "allowing the cars to take them at maximum speed of 60 miles per hour."

On September 10, 1908, plans were announced to christen the parkway with an event called Motor Parkway Sweepstakes, which was held a month later. The purpose of the contest was to create an opportunity to test the new parkway and the course, timing systems, and crowd control for the 1908 Vanderbilt Cup Race to be held on October 24. The circuit for the sweepstakes and the Vanderbilt Cup Race included the finished portion of the parkway and 14.45 miles of public roads.

The Long Island Motor Parkway officially opened on October 10, 1908, in conjunction with the five sweepstakes races. Cars entered the course through the three toll lodges that had been constructed that year. These were the Meadow Brook Lodge (Merrick Avenue, Westbury), the Massapequa Lodge (Massapequa-Hicksville Road, Plainedge), and the Bethpage Lodge (Round Swamp Road, Old Bethpage).

The parkway received excellent reviews from the public, newspapers, and automobile journals. In its October 15, 1908, editorial entitled "First of the Motorways is Opened," the magazine the *Automobile* predicted the impact of the parkway and the place of Vanderbilt in automobile history. The magazine called it "an epoch in motor-driven land transportation."

The 1908 Vanderbilt Cup Race was held over the same course as the Motor Parkway Sweepstakes. In conjunction with the construction of the parkway, a grandstand with a capacity of 5,000 spectators was built on the Hempstead Plains in today's Levittown. This race was won by an American, George Robertson, driving a Connecticut-made Locomobile. For the first time, America could finally boast of victory in an automobile race against international competition. The crowd that year was estimated at over 200,000 spectators along the 23.46-mile course.

In 1909 and 1910, the race was held on a shorter course than any previous Vanderbilt Cup Race, with the Motor Parkway making up only 5.51 miles of the total 12.64-mile distance. Organizers believed the shorter circuit would decrease the intervals of time between the appearances of cars and provide more exciting entertainment for spectators. Driver Harry Grant and his mechanician (driving mechanic) Frank Lee won both races in an American-built ALCO.

During the 1910 race, two driving mechanics were killed and several spectators were injured. Newspapers and trade journals harshly criticized the race organizers for the fatalities and injuries, citing crowd control as nonexistent. At this point, it became clear to everyone that after six years of controversy that accompanied each race, the sport had outgrown the venue. The two deaths from the 1910 contest effectively put an end to road racing on Long Island.

In 1909, the parkway was extended westward from Merrick Avenue in Westbury to Jericho Turnpike in Mineola and eastward from Bethpage to Dix Hills. Where the previously constructed roadway was 22 feet wide, the new extensions had a width of only 16 feet. By June 1912, 42.3 miles of the parkway were opened from Rocky Hill Road (Springfield Boulevard) in Queens to Lake Ronkonkoma. Initially it was planned to have inns for the travelers and automobile service facilities constructed throughout the length of the parkway. Due to financial considerations, these features were eliminated. Another casualty was the shortening of the projected length of the parkway. The eastern terminus would be on the western shore of Lake Ronkonkoma and never reach Riverhead.

Since the parkway was a toll road, gatekeepers were hired to collect the fees. The three lodges built in 1908 all had living accommodations for the toll collectors. By 1911, three additional lodges were constructed. All designed by John Russell Pope, they were the Great Neck Lodge at Lake Success, the Roslyn Lodge at East Williston, and the Garden City Lodge in the village of the same name. Two stories high, the lodges were constructed of stucco-covered brick with steeply pitched shingled roofs. The interior of each lodge contained a small office, a pleasant kitchen, and a large living room with a fireplace and stairs leading to two bedrooms above.

Over the next several years, additional entrances were built at six more locations, often with confusing names that did not match their actual locations. In Queens, examples are the Nassau Boulevard Lodge (Horace Harding Boulevard) and the Rocky Hill Road Lodge (Springfield Boulevard). Three additional lodges were built in Nassau County, the Jericho Turnpike Lodge (Mineola) and the aforementioned Great Neck and Roslyn Lodges. In Suffolk County, confusion was created with the Huntington Lodge in Melville and the Brentwood Lodge in Commack. Only the Ronkonkoma Lodge was properly labeled. Many Long Island maps also noted a toll lodge at Deer Park Avenue, but no building was ever constructed at this location, nor was this entrance ever manned. It was merely an entrance and an exit for the Long Island Motor Parkway.

The price of a round-trip was a rough measure of the parkway's popularity. When it opened in 1908, the toll was $2—roughly $45 today. In 1912, the toll was reduced to $1.50 and five years later reduced to $1. The toll fee held steady until 1933, when a dramatic drop in business due to the opening of the free Northern State Parkway occurred. At that time, the toll was reduced to 40¢. As previously noted, major roads and rail lines were bypassed with bridges. In 1908 alone, 18 bridges were built along the nine miles of roadway. For the most part, the bridges have clearances of 14 feet. This allowed even wagons piled high with hay to pass underneath easily. Overall, 65 bridges were built by the parkway. For many years, many of them remained in place as reminders of a different time. Those not demolished previously disappeared during the 1950s and 1960s, during the population explosion and road-widening projects on Long Island at that time. Demolition crews were amazed at the durability of bridges built with 50-year-old technology.

When the route to Lake Ronkonkoma was completed in 1911, parkway officials decided to build a high-society inn on the lake. Vanderbilt commissioned John Russell Pope to design a smaller version of the Petit Trianon, a small building on the grounds at Versailles, near Paris. Pope borrowed many of the features of the French original, including the general rectangular shape, the symmetrical facade with tall windows, and a restrained use of exterior decoration. Small one-story pavilions flanked the structure, providing seating and lounge areas. A large dining room suitable for weddings, balls, and special events occupied the first floor. Accommodations for spending a night or a weekend were available in the 30 bedrooms on the second floor.

The Petit Trianon Inn was in business for 15 years, with many parties held for Long Island's elite motoring set. The inn later became a club and restaurant under various ownerships. On

January 11, 1958, the structure was destroyed by fire. After five hours of battling the blaze, the landmark building had been totally destroyed.

In the 1920s, the parkway benefited as the automobile became more commonplace in the lives of ordinary Americans. To serve the ever-growing number of motorists, the parkway was once again extended an additional 2.1 miles to the west. The new western terminus was now at Nassau Boulevard (Horace Harding Boulevard) in Fresh Meadows, Queens. The total length of the parkway was now 44.0 miles from end to end.

The last construction commissioned by the parkway was a spur built in 1929 at Commack in Suffolk County. It was 2.1 miles long, connecting Jericho Turnpike with the Long Island Motor Parkway. Today the spur is known as Harned Road.

Over the course of its 30-year history, the parkway became a conduit for the development of Long Island and heralded the transformation of the island from a rural area to a sprawling suburbia. At the peak of its popularity from 1924 to 1930, more than 150,000 cars traveled on the Long Island Motor Parkway. Even when business was booming, however, the parkway was a money-losing proposition. In an effort to keep it open, Vanderbilt personally made numerous loans to keep it afloat. Vanderbilt and his associates never made a profit on their estimated $5 million investment. In 1929, a group of Nassau County millionaires tried to convince the state to purchase the parkway rather than build the Northern State Parkway through their properties. Noting its narrow 22-foot width and curves, Robert Moses, then head of the Long Island Park Commission, described the Long Island Motor Parkway as a white elephant that would "be given to Nassau and Suffolk Counties for nothing some day." The crushing impact of the Depression, coupled with the ever-expanding free New York State Parkway system, effectively sealed the fate of the narrow winding Motor Parkway. On June 16, 1937, Moses's prediction became a reality when Vanderbilt offered the parkway to the public. It officially closed on Easter Sunday, April 17, 1938. Shortly thereafter, the right-of-way was turned over to Queens, Nassau, and Suffolk Counties in return for the cancellation of $80,000 real estate back taxes.

Remnants of the Long Island Motor Parkway still exist to this day in different forms including: pavement, bridges, concrete guard rail posts and right-of-way boundary posts. The Queens portion was originally turned into a public bicycle path, and today most of it is still in existence as a ribbon park connecting Cunningham Park and Alley Pond Park. Nassau County incorporated small sections into its road system, and other portions were turned over to utility companies for power lines. Some pieces were sold off to developers. Of the 17 original miles in Suffolk County, the easterly 13 miles were incorporated into its road system, and this section is now known as County Road 67.

One

ORIGINS OF THE MOTOR PARKWAY

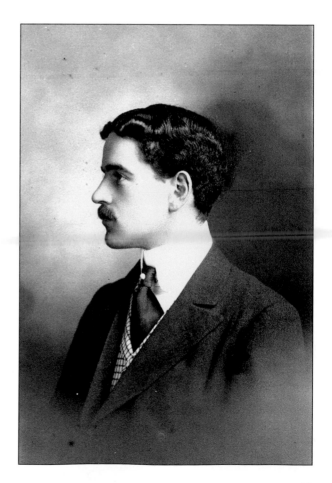

The force behind the Long Island Motor Parkway was William K. Vanderbilt Jr. (1878-1944), great-grandson of shipping and railroad tycoon Commodore Cornelius Vanderbilt. "Willie K.," as he was called by his friends, was an avid sportsman, accomplished yachtsman, and skilled automobile racing pioneer. In 1900 and 1901, he raced and won automobile races at Aquidneck Park, a half-mile horse track in Newport, Rhode Island. (Courtesy of the Suffolk County Vanderbilt Museum.)

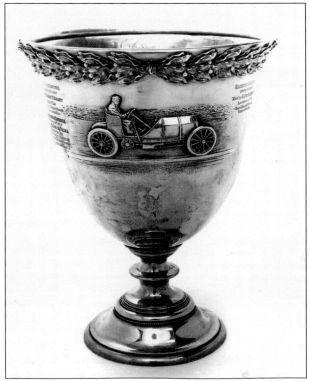

TWENTY-MILE AUTO SPEEDWAY IS PLANNED FOR LONG ISLAND.

Route of Proposed Auto Spe dway Through Long Island.

Dotted lines on the map printed above show the course of the private road between Long Island City and Roslyn, L. I. The likeness is that of W. K. Vanderbilt, Jr., one of the millionaire promoters.

W. K. Vanderbilt, Jr., W. C. Whitney a id Other Millionaires Said to Be Interested in Building a Great Private Highway for Automobile Speeding.

As early as 1902, William K. Vanderbilt Jr. and his friends sought to build a road specifically for automobiles on Long Island. The road was to begin at the ferry landing at Long Island City and end in Roslyn and then later extended to Montauk Point. Nothing came out of this early attempt at a private automobile roadway. (Courtesy of the Suffolk County Vanderbilt Museum.)

On January 8, 1904, the 26-year-old Vanderbilt proposed to officials of the newly formed American Automobile Association (AAA) to sponsor such a race on Long Island. He donated a 10.5-gallon, 30-pound silver cup designed by Tiffany and Company. Embossed on the precious metal was the image of Vanderbilt in his proudest racing moment, atop his Mercedes at the 1904 Ormond-Daytona Beach Automobile Tournament while breaking the one-mile land speed record at 92.3 miles per hour. (Courtesy of the Suffolk County Vanderbilt Museum.)

RACING AUTOS KILL AND MAIM IN TERRIFIC FLIGHT

For the 1906 Vanderbilt Cup Race, fans from all over the country swarmed to Long Island to witness the battle of automobiles from the United States, France, Germany, and Italy. Some reckless spectators, among the 250,000 spectators present that day, once again surged onto the narrow dirt public roads to view their favorite drivers. Among the many race attendees persistently crowding the course that day was Curt Gruner, a 33-year-old mill foreman from Passaic, New Jersey. Tragically, Elliot Shepard Jr.'s Hotchkiss struck Gruner down on the sixth lap, killing him. (Courtesy of the Suffolk County Vanderbilt Museum.)

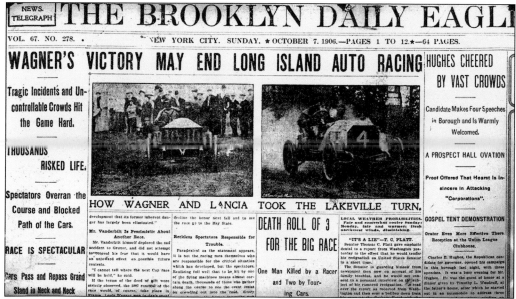

While the trade journals and press praised the entertainment value of the 1906 Vanderbilt Cup Race, they noted that the huge crowds and risks to the spectators would preclude future races from continuing to operate on public roads. Two days after the race, on October 9, 1906, AAA president John Farson appointed a special committee to look into developing a privately owned speedway.

LONG ISLAND MOTOR PARKWAY, INC.

527 FIFTH AVENUE.

WILLIAM K. VANDERBILT, JR., - - - - *President*

HARRY PAYNE WHITNEY, - - - - *Vice-President*

A. R. PARDINGTON, - - - - *2d Vice-President*

JEFFERSON DE MONT THOMPSON, - - - *Treasurer*

PLAN AND SCOPE COMMITTEE

WILLIAM K. VANDERBILT, JR., JEFFERSON DE MONT THOMPSON

RALPH PETERS, A. R. PARDINGTON,

DAVE HENNEN MORRIS, DEAN ALVORD.

FINANCE COMMITTEE

C. T. BARNEY, *Chairman*

WILLIAM K. VANDERBILT, JR., RALPH PETERS,

H. B. HOLLINS, JEFFERSON DE MONT THOMPSON.

DIRECTORS AND INCORPORATORS

AUGUST BELMONT,	HARRY PAYNE WHITNEY,
WILLIAM K. VANDERBILT, JR.,	CLARENCE H. MACKAY,
COLGATE HOYT,	H. B. HOLLINS,
LEVI C. WEIR,	ANTON G. HODENPYL,
FREDERICK G. BOURNE,	A. R. PARDINGTON,
RALPH PETERS,	JEFFERSON DE MONT THOMPSON,
DAVE HENNEN MORRIS,	JOHN FARSON,
J. ADOLPH MOLLENHAUER,	HOWARD K. BURRAS,
AUGUST HECKSCHER,	DEAN ALVORD,
W. G. McADOO,	S. T. DAVIS, JR.,
C. T. BARNEY,	E. R. THOMAS,
MORTIMER SCHIFF,	E. RAND HOLLANDER,
JOHN JACOB ASTOR,	HENRY FORD.

At an October 18, 1906, meeting, William K. Vanderbilt Jr. was announced as a president of a newly formed Automobile Highway Association. On November 16, 1906, the name was changed to Long Island Motor Parkway, Inc. The officers were Vanderbilt, president; Harry Payne Whitney, vice president; A. R. Pardington, second vice president; and Jefferson De Mont Thompson, treasurer. Pardington, who was also the parkway's general manager, proudly called the board of directors "the most remarkable directorate ever gotten together." Some of the more recognizable names included Henry Ford, John Jacob Astor, August Belmont, Mortimer Schiff, Clarence Mackey, and Frederick G. Bourne.

PROSPECTUS

OF

LONG ISLAND MOTOR PARKWAY

INCORPORATED

1906

The Long Island Motor Parkway, Inc., to be organized and incorporated for the purpose of acquiring on Long Island a right of way approximately 100 feet wide and fifty miles long. Beginning at a point near the City Line of Greater New York, the Parkway will have its eastern terminus near the shore of Peconic Bay, Suffolk County. On this right of way there will be constructed an automobile parkway, properly fenced to protect users.

It is proposed to charge for the use of this Parkway, and establish reasonable regulations as to its use.

The revenues from this and other sources, are conservatively estimated to more than pay all fixed charges, known and estimated. The sources of revenue are as follows:

A : Charges on an annual, semi-annual, quarterly, monthly, weekly, daily and hourly basis.

B : Admissions, sale of seats, parking spaces, etc., in connection with events similar to the race for the William K. Vanderbilt, Jr., Cup.

C : Testing of cars by manufacturers.

D : Match races, economy tests, non-stop tests, twenty-four hour contests, etc.

The Long Island Motor Parkway, Inc., will afford manufacturers, agents and others the opportunity they so greatly need of trying out their products under true road conditions, where there exist no speed regulations. Buyers of cars at the present time find it difficult to so test cars as to know that their requirements have been complied with. This particular feature so appeals to engineers and designers of racing and touring cars as to have called forth unanimous expressions of approval and support.

Of the twenty-five Directors serving on the Board, but three have trade affiliations. These three represent the three powerful trade organizations which control the manufacture and importation of cars in this country.

Long Island, convenient as it is to New York City, is daily becoming more and more a place of year-round residence by owners of motor cars. The scenery through which the Motor Parkway is to pass comprises level stretches, numerous hills, views of the Sound and Ocean, passing lakes and many large estates.

The Long Island Motor Parkway, Inc., is a necessity. The use of the much-frequented highways of the Island by motorists has become irksome and expensive.

All railroads and highways will be crossed above or below grade. These highways, crossing the Island from north to south, will, in time, undoubtedly, be improved and act as valuable feeders to the Parkway, make it convenient for those who desire to ride daily to and from New York.

Co-incident with the completion of the Blackwell's Island Bridge, the City of New York is planning vast improvements to the Boulevard System of Queens Borough. Liberal speed ordinances are contemplated, which will make high speed between Manhattan and points along the Motor Parkway permissible.

The Long Island Motor Parkway, Inc., prospectus was issued on November 19, 1906, and officially proclaimed the company's intentions and positive outlook for success. The document described a right-of-way that was 100 feet wide and 50 miles long, beginning near the New York City line and ending near Riverhead in Suffolk County.

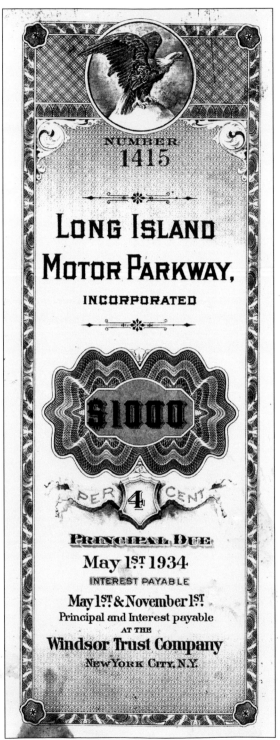

NUMBER
1415

LONG ISLAND MOTOR PARKWAY,

INCORPORATED

$1000

PER 4 CENT

PRINCIPAL DUE

May 1ST 1934

INTEREST PAYABLE

May 1ST & November 1ST

Principal and Interest payable

AT THE

Windsor Trust Company

New York City, N.Y.

The Long Island Motor Parkway, Inc., incorporated as a public stock company. In conjunction with the stock offering, bonds in increments of $1,000 paying 4 percent interest were also sold. A total of $1 million worth of bonds was acquired by investors.

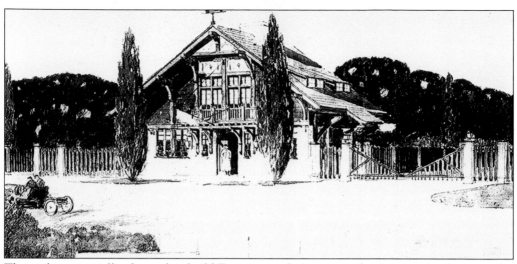

The parkway initially planned to build European-style inns at each entrance. As shown in the architect's design, the inns had lodging and refreshments available and an adjoining garage to provide gasoline and automobile supplies. Due to financial considerations, the inns were never built and were replaced by toll collection stations designated as lodges. The proposed inns and the first six lodges were designed by John Russell Pope, who would later attain worldwide fame as the architect for major estates and government buildings, including the Jefferson Memorial and the National Gallery of Art. (Courtesy of the Suffolk County Vanderbilt Museum.)

The Committee on Plan and Scope of the Long Island Motor Highway, Inc. consisting of

WILLIAM K. VANDERBILT, Jr., Chairman,

RALPH PETERS, JEFFERSON DE MONT THOMPSON, A. R. PARDINGTON and DEAN ALVORD, is now ready to receive formal offers of rights of way one hundred feet in width through any properties lying between the main line and the Port Jefferson branch of the Long Island Railroad. Six different routes have been projected within the limits named. The land through which most liberal concessions are made will determine the final route.

Specific offers accompanied so far as possible by a sketch showing locations of properties will be received by the undersigned until November 15th, and should be addressed to

DEAN ALVORD, 277 Broadway, N. Y. C.

Beginning in November 1906, parkway officials sought to acquire the right-of-way from farmers and property owners of Long Island. The campaign was managed by A. R. Pardington, general manager and second vice president, and Dean Alvord, a major real estate broker who had developed the Roslyn Estates and Brooklyn Prospect Park South communities.

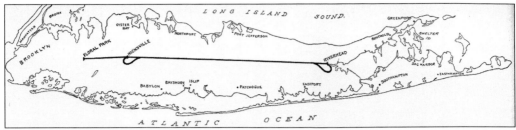

As described in the October 25, 1906, issue of the automobile trade journal the *Automobile*, the initial Long Island Motor Parkway concept was a "straightaway road of 65 miles that will extend from Floral Park through the center of Long Island to Riverhead." By providing wide loop turns in Hicksville and Riverhead and a 50-foot-wide road, it was planned that the speedway would be used for several international automobile competitions, including the Vanderbilt Cup Races.

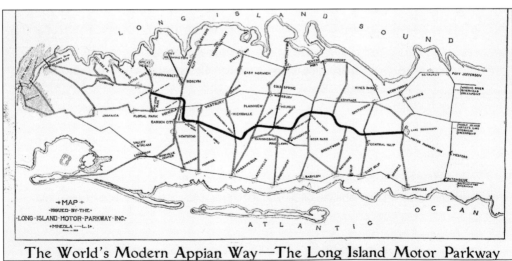

The World's Modern Appian Way—The Long Island Motor Parkway

The route that the parkway would ultimately take across Long Island differed greatly from the initial straightaway course concept. Without the right of condemnation, the right-of-way was determined by landowners willing to accommodate the parkway organizers. This 1910 map published by the parkway dramatically shows all the twists and curves between Lakeville Road at Lake Success and Lake Ronkonkoma.

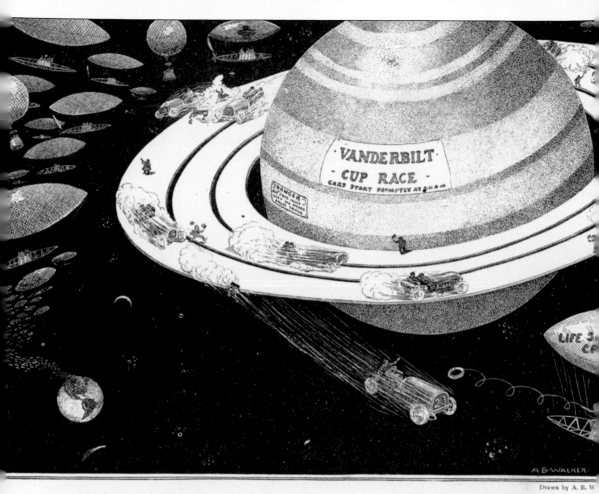

Drawn by A. B. W

A SPEEDWAY SOLUTION—THE POSSIBILITIES OF SATURN ARE UNSURPASSED

The prospect of a speedway for the 1907 Vanderbilt Cup Races was highly anticipated by racing fans. This cartoon in the March 16, 1907, issue of *Harper's Weekly* sarcastically suggested moving the race to Saturn as a solution to the crowd control problem and minimizing the dangers to race spectators. Delays in obtaining the right-of-way for the Long Island Motor Parkway resulted in the cancellation of the 1907 Vanderbilt Cup Race, and construction did not begin until 1908.

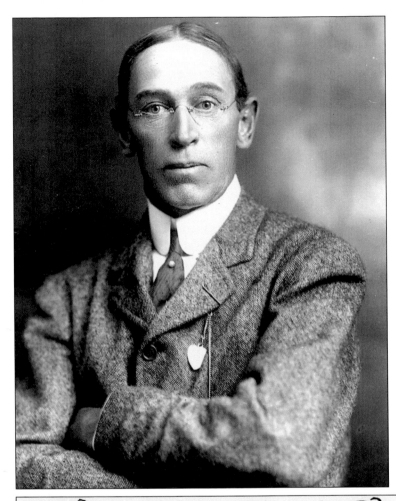

The Long Island Motor Parkway was heavily promoted in automobile trade journals and throughout the metropolitan area of New York City by general manager A. R. Pardington, a resident of Smithtown. His three-page article in the March 16, 1907, issue of *Harper's Weekly* extolled the virtues of "The Modern Appian Way for the Motorist." (Courtesy of the Suffolk County Vanderbilt Museum.)

The New York Times.

NEW YORK, SUNDAY, OCTOBER 21, 1906.—44 PAGES, In Five Parts, Including Pictorial Section.

60-MILE AUTO ROAD TO COST $2,000,000

Vanderbilt Race Projectors to Build It on Long Island.

NO MORE RACING DANGERS

Speedway to be for All Who Pay Toll —Will Have Inns and Garages Along the Route.

STAND FALLS WITH 400.

Many Spectators at a Syracuse Foot-Ball Game Are Injured.

SYRACUSE, Oct. 20.—In the course of the football game between the teams from Syracuse and Colgate Universities at New Star Park here this afternoon, a portion of the upper section of the bleacher stands collapsed. Four hundred persons were precipitated into the inclosure under the stands. One hundred or more were injured, and the death of three is expected.

The Rev. Christopher J. Donigan, assistant pastor of St. John the Evangelist's Church, suffered an injury which

CAPT. WHEELER LOSES $60,000 BY FORGERIES

Ex-Army Officer's Nephew Held at Police Headquarters.

UNCLE FORGAVE HIM ONCE

Arthur C. Babbitt Is the Prisoner's Name—Charles Gates Cashed Checks for Him.

STORKS FOR WHITE HOUSE.

Sent Over on the America to the President—Who Did It?

There will be delivered at the White House, in Washington, this afternoon, a pair of white storks. The birds arrived here yesterday on the Hamburg-American liner America, consigned to President Roosevelt. Who sent the birds was not known aboard ship. One passenger suggested that the donor was possibly the Kaiser.

The birds were kept in a big cage on the main deck of the liner, and according to the sailor whose particular job it was to see that the birds lacked for nothing on the way over, better behaved birds never

The announcement of the proposed speedway made front-page headlines throughout New York and the automobile trade journals. On October 21, 1906, the front page of the *New York Times* described the planned 60-mile auto road: "Automobilists are to have a speedway of their own on Long Island in the near future and it will be open to all pleasure motors. Access will be given to it through tollgates placed at convenient intervals. At each tollgate will be established an inn on the plan of the hostelries of England, where automobilists will be able to obtain refreshments. To each inn a garage will be attached, where gasoline tanks and storage batteries may be charged and repairs effected."

Two

GROUNDBREAKING

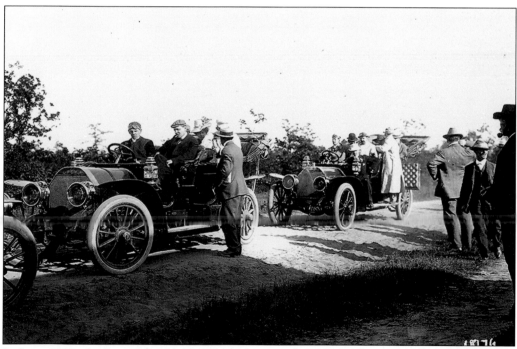

In June 1908, the Long Island Motor Parkway staged an official groundbreaking ceremony to commemorate the beginning of parkway construction. Shown here arriving at the site are parkway officials, guest speakers, and other dignitaries on Jerusalem Road in Central Park (now Bethpage). The man standing alongside the automobile on the left is Russell A. Field, the secretary of the Long Island Automobile Club and a speaker for the festive event. To his right, standing on the running board of the other automobile, is Jefferson De Mont Thompson, the parkway's treasurer.

LONG ISLAND MOTOR PARKWAY
INCORPORATED

THE LONG ISLAND MOTOR PARKWAY, INC., ANNOUNCES TO THE PUBLIC THAT MR. WILLIAM K. VANDERBILT, JR., PRESIDENT OF THE PARKWAY COMPANY WILL INAUGURATE THE WORK OF CONSTRUCTION ON SATURDAY AFTERNOON, JUNE THE SIXTH, AT THREE THIRTY O'CLOCK, ON "THE BARNES TRACT," JERUSALEM ROAD, CENTRAL PARK, LONG ISLAND.

THE PRESS, MOTORISTS AND THE PUBLIC ARE INVITED TO CO-OPERATE IN MAKING THIS EVENT A RED-LETTER DAY FOR MOTORISTS.

A. R. PARDINGTON,
2ND V.-P. AND GEN. MGR

MAY 23, 1908.

SEE OTHER SIDE FOR MOTOR ROUTES AND TRAIN SCHEDULES TO CENTRAL PARK.
IN THE EVENT OF INCLEMENT WEATHER, POSTPONEMENT FOR ONE WEEK.

Invitations to the groundbreaking ceremonies were sent out by William K. Vanderbilt Jr. to automobilists, high society, and supporters of the Long Island Motor Parkway. If invitations were sent out today, people would be directed to the northwest corner of Stewart Avenue (then called Jerusalem Road) and Albergo Court in Bethpage. (Courtesy of the Suffolk County Vanderbilt Museum.)

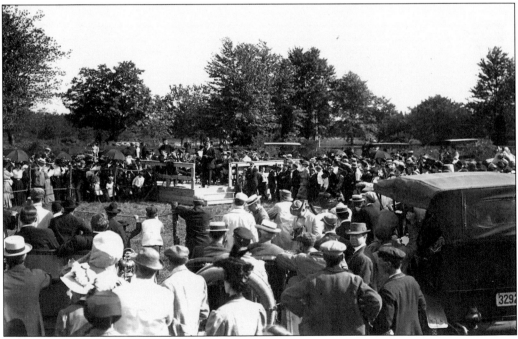

Approximately 500 people were in attendance to listen to speeches from dignitaries and witness the ceremonial turn of earth. Not all present that day came by automobile. The horse and bicycle were well represented. A large number of well-dressed women carrying umbrellas also turned out on what was a bright sunny day. Hosting the activities and welcoming the crowd from what was described as "a rough grandstand" was A. R. Pardington. (Courtesy of the National Automotive History Collection, Detroit Public Library.)

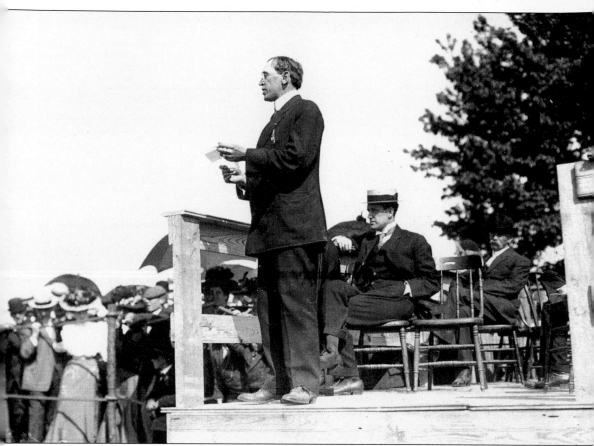

The original plan called for Vanderbilt to make a speech and turn the sod, but the sudden and grave illness of his stepfather, Oliver Hazard Perry Belmont, kept him away. Pardington read from Vanderbilt's prepared remarks. He praised the impact and potential of the automobile: "The automobile has come into such prominence that it has revolutionized all mode of travel. Distance has been eliminated, highways improved, unknown districts opened up, and pleasure given to thousands . . . land owners in almost every case, seeing what a benefit a road of this character would be to their property, gladly came forward with help, enabling us to complete a forty-five mile right of way." (Courtesy of the Garden City Archives.)

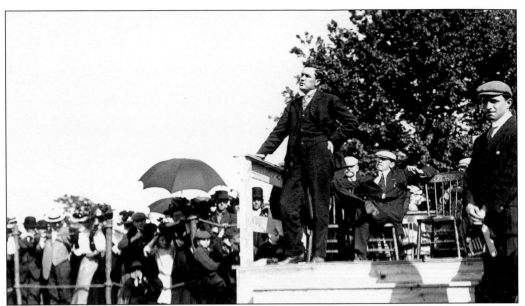

Russell A. Field, the secretary of the Long Island Automobile Club and the automobile editor for the *Brooklyn Daily Eagle*, extolled the benefits of what roads such as the parkway would do for touring and sightseeing and at the same time provide a safe venue for automobile racing and other speed contests. (Courtesy of the Garden City Archives.)

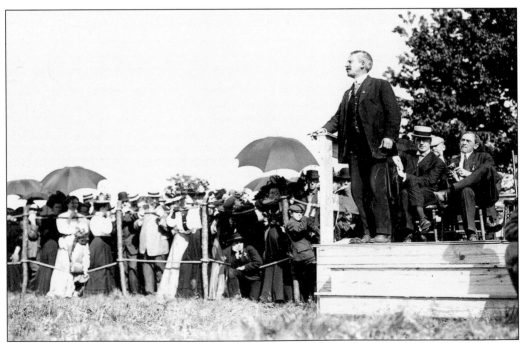

John C. Wetmore, considered the dean of New York automobile writers, also took the podium. He lavishly praised William K. Vanderbilt Jr. and the other parkway organizers for their vision and foresight in conceiving the Long Island Motor Parkway and bringing it to fruition. (Courtesy of the Garden City Archives.)

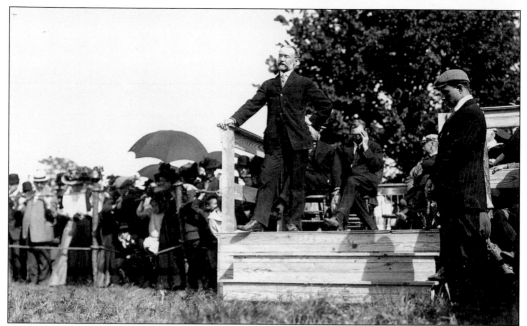

August Heckscher, a Huntington resident and a parkway director, commented on the benefits that roads such as the parkway would bring to Long Islanders. Heckscher is best remembered by the state park on Great South Bay in Islip Township bearing his name. (Courtesy of the Garden City Archives.)

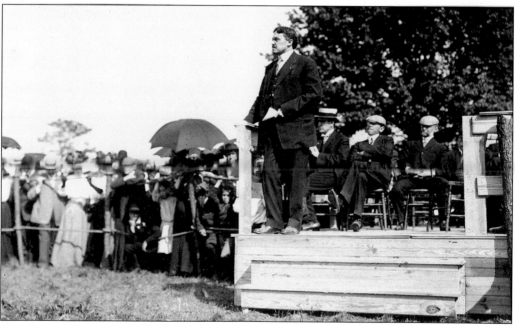

Another speaker was Judge William H. Hotchkiss, president of the AAA. An ardent automobilist, his well-chosen words prophetically foresaw how automobile ownership would someday be within the reach of the everyday workingman. "Such roads, limited to the new vehicle especially constructed for it, like the railroad, have become necessary, and the Long Island Motor Parkway is the first of such roads anywhere in the world." (Courtesy of the Garden City Archives.)

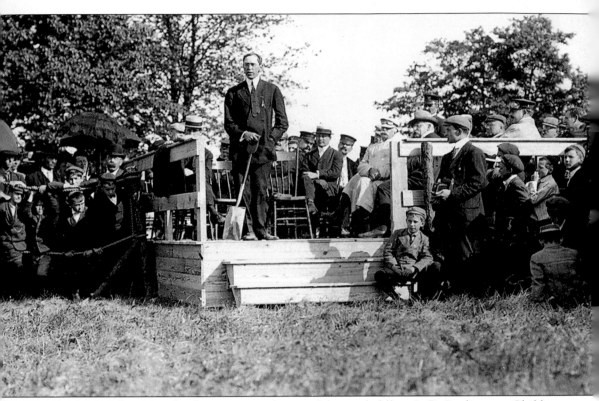

The honor of turning the first ceremonial turn of the earth fell to A. R. Pardington. Children of the speakers and dignitaries surrounded the makeshift podium. (Courtesy of the Garden City Archives.)

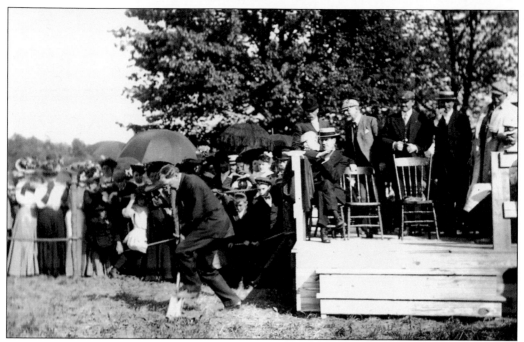

Pardington, putting his best foot forward under the watchful eyes of those present that day, eagerly digs into the sandy Long Island soil with a golden shovel. (Courtesy of the National Automotive History Collection, Detroit Public Library.)

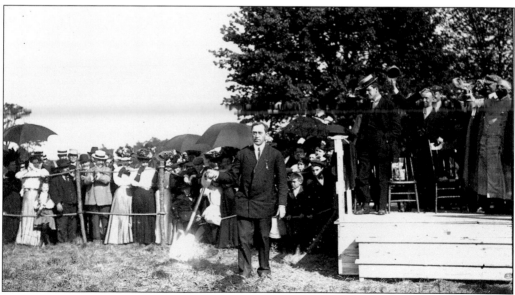

Mission accomplished. Note the applause accompanied by cheers and the waving of hats by the dignitaries. One could almost feel the satisfaction of the arrival of this momentous day. (Courtesy of the Suffolk County Vanderbilt Museum.)

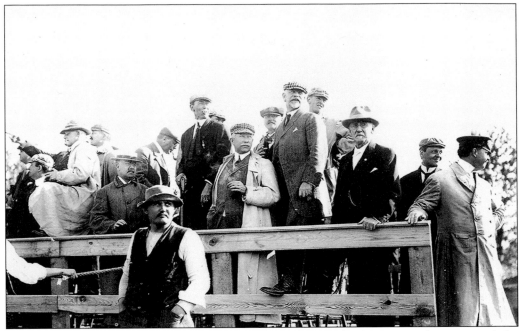

Following the earth turning, E. G. Williams, the parkway's chief engineer, demonstrated the clearing of tree stumps by the use of dynamite. Those on the grandstand turned as one toward the blasts. The man wearing the long white coat is Jefferson De Mont Thompson (center), the parkway's treasurer. On his right, standing on a chair, is Pardington, still clutching the ceremonial shovel. (Courtesy of the Suffolk County Vanderbilt Museum.)

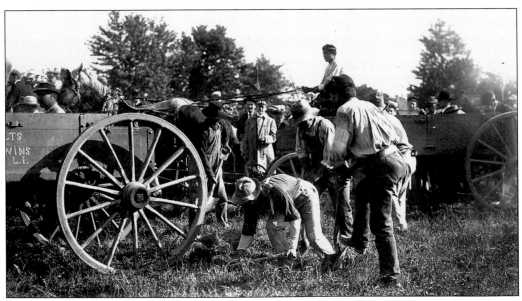

No sooner had the din of the dynamiting had died down, than a large group of Italian laborers appeared and began removing topsoil and shoveling it into large-wheeled wagons. Although late in the day, those gathered were witnessing real work of the parkway's construction, the proverbial first step in the 44-mile march across Long Island. (Courtesy of the Suffolk County Vanderbilt Museum.)

Three

BUILDING THE PARKWAY

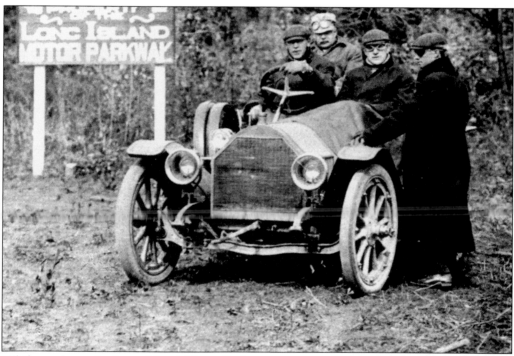

While work on the Long Island Motor Parkway, consisting primarily of surveying and land clearing, had begun in May 1908, serious construction started in June of that year. Pictured on an inspection tour are A. R. Pardington (left) at the wheel and parkway officials. The general contractor for the work was the Ridgefield Land Company. Pardington was a hands-on general manager and would often survey the progress of the construction with parkway officials, as shown above. (Courtesy of the Garden City Archives.)

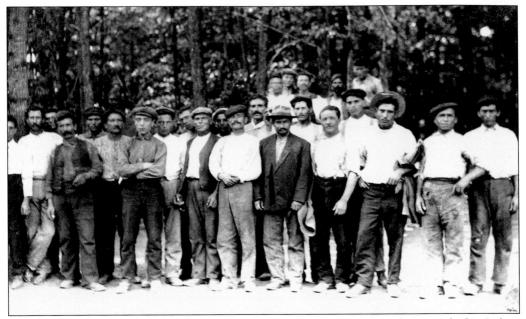

The job of building the Long Island Motor Parkway was conducted primarily by Italian immigrants who spoke very little English. Over the next three years, the parkway employed over 600 workers. (Courtesy of the Garden City Archives.)

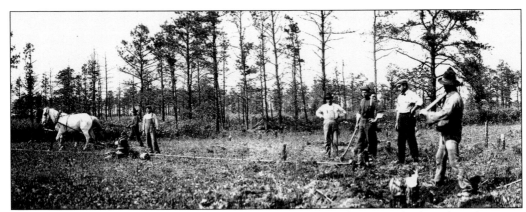

Prior to the actual construction, the land had to be cleared of trees and other obstacles. Seen here are laborers at work removing small stumps by horsepower. (Courtesy of the Garden City Archives.)

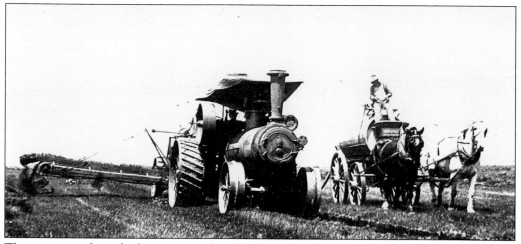

The transition from the horse-powered age to the 20th century mechanical era was never more evident than in the construction of the parkway. The steam-powered tractor is removing topsoil from what will be the 22-foot-wide roadway. The horse-drawn wagon is carrying a tank full of water, replenishing the tractor's supply as needed. (Courtesy of the Handley Collection at the Smithtown Library.)

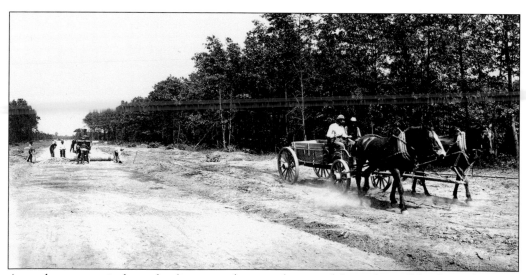

A two-horse team is shown hauling away the topsoil removed from what will be the 22-foot-wide roadway. In the distance, workers are grading and leveling the cleared areas. From time to time, it was necessary to cut a swath through a stand of trees before construction could begin, as shown behind the workers. (Courtesy of the Suffolk County Vanderbilt Museum.)

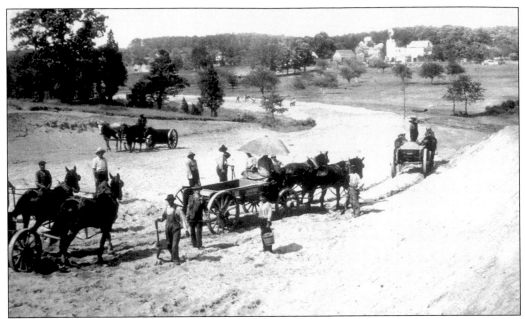

The movement of topsoil and excavated material was a slow and tedious process; many wagons were required, as they had a capacity of only three cubic yards, the most a two-horse team could haul. This section of the Long Island Motor Parkway is in Bethpage north of Central Avenue. In the distance can be seen the William Stymus farm. The buildings were located on the east side of Stymus Avenue between Thorne Drive and Prospect Street. (Courtesy of the Handley Collection at the Smithtown Library.)

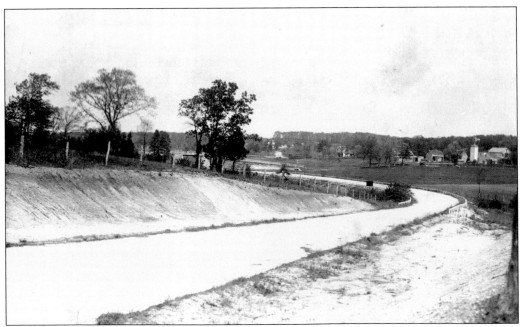

This is the same location as the above image as it looked in 1910. Note the warning sign at the curve to encourage automobiles to slow down. (Courtesy of the Suffolk County Vanderbilt Museum.)

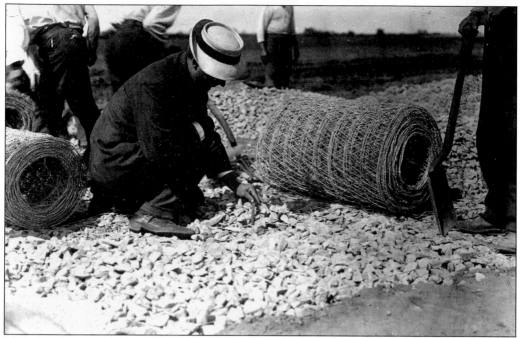

This is a close-up of the wire reinforcement and the traprock base in preparation for a concrete cap. At the time, it was a unique practice and a basis for the patent known as the Hassan Process. E. G. Williams, the parkway's chief engineer, is showing the laborer how much cover he wants on the wire screen. (Courtesy of the Garden City Archives.)

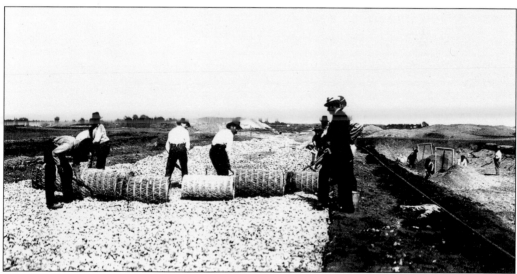

Shown here under the careful observation of Williams is the placement of stone over the wire reinforcement. The two laborers in the center of the roadway seem to be inquiring, "Basta cusi?" ("Is that enough?") On the right is a water pipe line from one of the wells dug by the Long Island Motor Parkway. In the background are mounds of soil framing the roadway. These are the approaches of a bridge to be built over the parkway. (Courtesy of the Garden City Archives.)

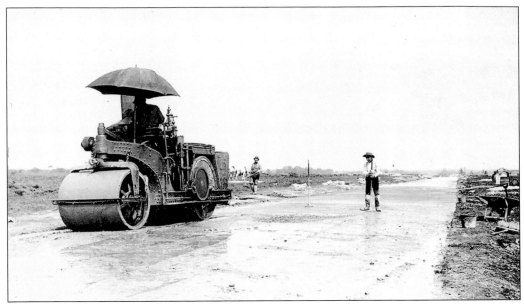

Shortly after being applied, the slurry mix was compacted into the stone base and through the wire reinforcement. Although barely perceptible in this photograph, there is a slight crown down the center of the roadway. (Courtesy of the Suffolk County Vanderbilt Museum.)

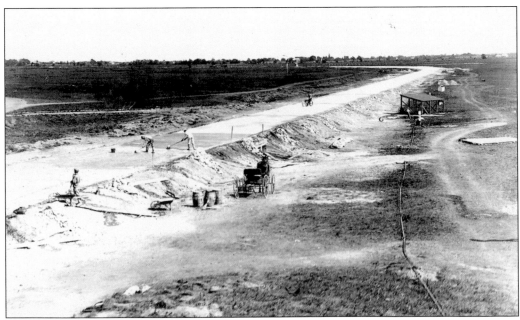

Here the barely dried concrete surface was being rough-swept to create a slightly abrasive finish. It was done at a right angle to the roadway to facilitate the drainage of rainwater. Even though the Hempstead Plains were relatively flat, as shown in this photograph, sections of the Long Island Motor Parkway had to be raised in order to maintain a constant grade. The location of the image is south of today's Bloomingdale Road in Levittown. (Courtesy of the Suffolk County Vanderbilt Museum.)

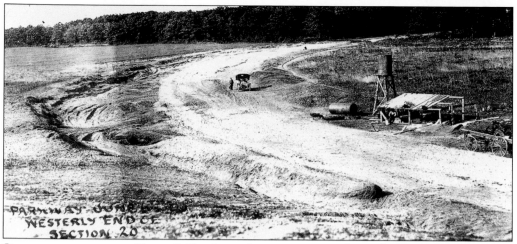

Since water was not readily available, the parkway contractors dug wells every mile or so along the construction zone. On the right is a typical well setting with a pump station and elevated water storage tanks. This particular well was located west of Plainview Road in Bethpage. (Courtesy of the Suffolk County Vanderbilt Museum.)

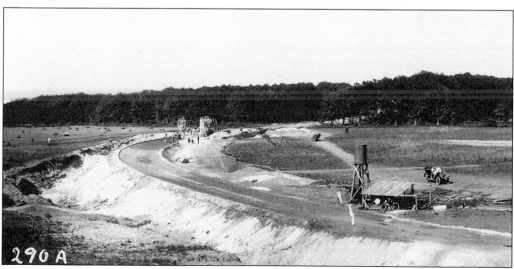

This is the same scene shown later during construction. Note that the curved section of the roadway has been banked and elevated. In the distance beyond the curve, forms are being put in place for the pouring of concrete embankments for the bridge that will take Plainview Road over the Long Island Motor Parkway. (Courtesy of the Garden City Archives.)

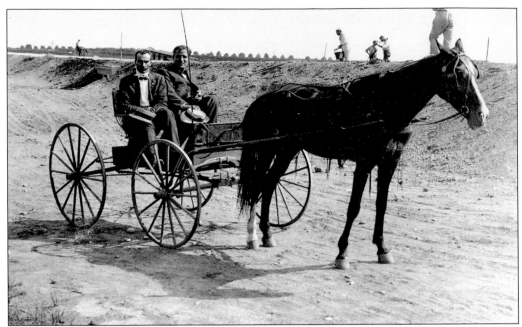

Superintendent Howard Mills and engineer Albert Barnes of the Hassan Paving Company are shown on a tour of the progress of construction, their horse-drawn mode of transportation common at the time. This would be their only opportunity to ride a horse on the Long Island Motor Parkway, as when opened to the public use would be restricted to automobiles exclusively. (Courtesy of the Garden City Archives.)

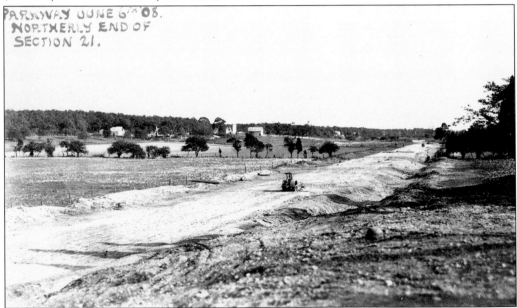

This long, broad vista looks south from Powell Avenue in Bethpage. The picturesque and bucolic setting, with the Stymus farm on the left, was typical of the Long Island that was used for farming. To capture this June 5, 1908, image, it was necessary for the photographer to stand on the west side ramp of the bridge that would take Powell Avenue over the parkway. (Courtesy of the Suffolk County Vanderbilt Museum.)

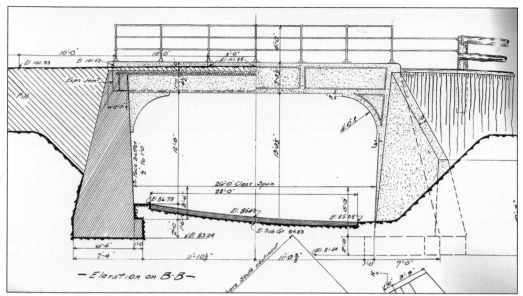

A construction drawing is shown of the bridge that would take Stewart Avenue in East Meadow over the parkway. The design of the bridge is typical of those used by the parkway. Height clearance would be in the 12-to-14-foot range with a minimum width of 26 feet. This design would allow for a 2-foot-wide drainage area on both sides of the 22-foot-wide roadway. (Courtesy of Town of Hempstead Archives.)

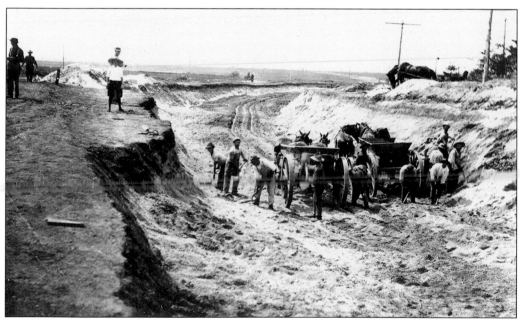

A total of 65 bridges were built on the parkway over and under major crossroads, railroad tracks, a trolley line, and, as part of right-of-way agreements, to connect farmlands. Several sections of the Long Island Motor Parkway were excavated to depths of more than 10 feet, all by hand. Workers shown above were digging a section of the parkway that would go under the soon-to-be-built Stewart Avenue Bridge in East Meadow. (Courtesy of the Handley Collection at the Smithtown Library.)

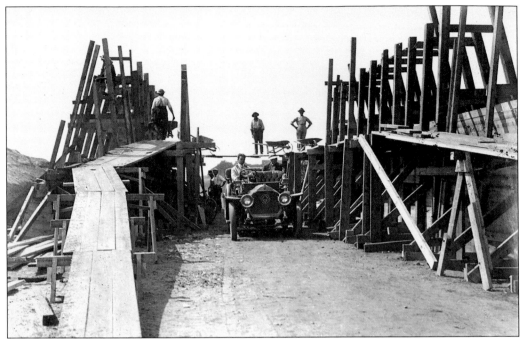

The construction of the Long Island Motor Parkway bridges was a slow and time-consuming process. Shown here are the concrete embankments being poured, one wheelbarrow at a time. The worker on the left side ramp still has to pour his load of concrete. After doing so, he will join the other two men with empty wheelbarrows and come down the ramp on the right side. (Courtesy of the Garden City Archives.)

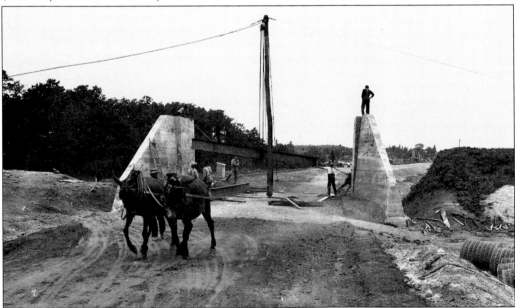

The process of putting the steel bridge girders in place, although primitive, was simplicity itself. A tall pole was erected in the center of the roadway with a pulley at the top. The girder would then be raised by a team of horses to the desired height, turned, and placed on top of the embankments. (Courtesy of the Garden City Archives.)

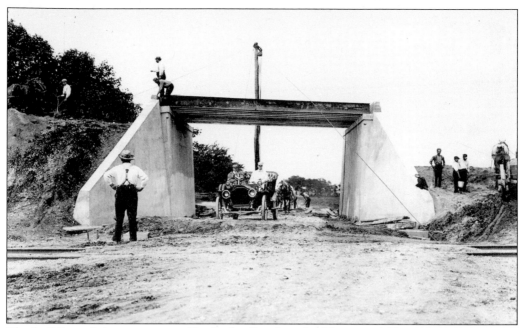

The building of the ramps over Newbridge Road in the Hempstead Plains (now Levittown) is shown underway with the girders in place. The process is being observed by unidentified parkway officials. In the foreground are the tracks of the Central Railroad Division of the Long Island Rail Road. (Courtesy of the Garden City Archives.)

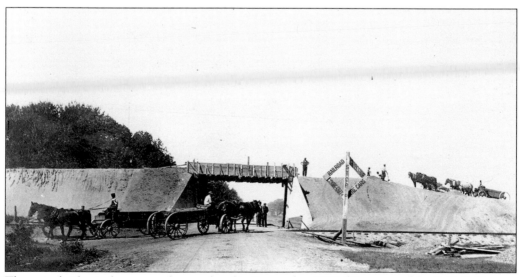

The same bridge is shown nearly completed in September 1908. (Courtesy of the Suffolk County Vanderbilt Museum.)

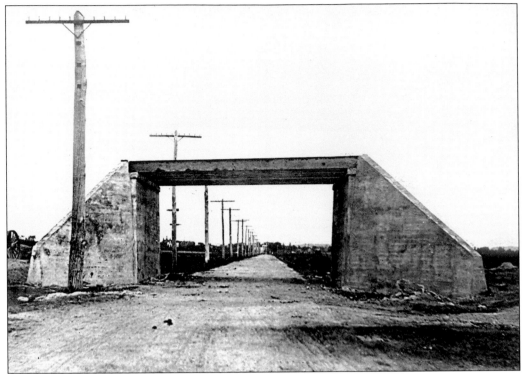

The construction of the bridge over Merrick Avenue in East Meadow is shown here in August 1908. The tall bridges built by the Long Island Motor Parkway dramatically and permanently changed the character of the Hempstead Plains. (Courtesy of the Suffolk County Vanderbilt Museum.)

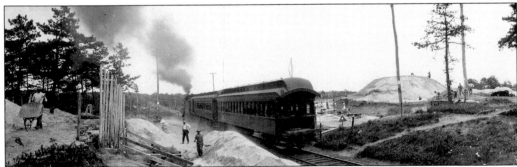

Of the 65 bridges built by the Long Island Motor Parkway, the one over the Long Island Rail Road and Central Avenue in Bethpage at 90 feet was the longest. Shown here are the earliest stages of construction. On the right, the building of the south earth ramp that will lead to the bridge is well underway. On the left, the erection of the forms for the concrete embankments has begun. (Courtesy of the Garden City Archives.)

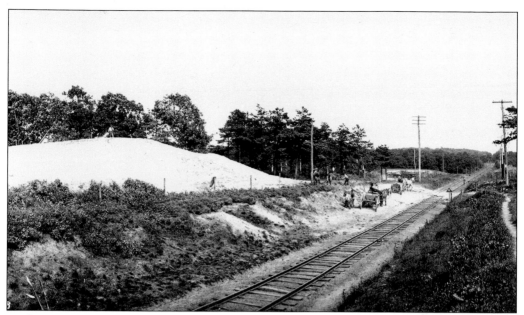

Looking east, the north earth ramp for the Central Avenue/Long Island Rail Road bridge is seen in June 1908. Note that Central Avenue crosses the railroad tracks at the top of the image. (Courtesy of the Garden City Archives.)

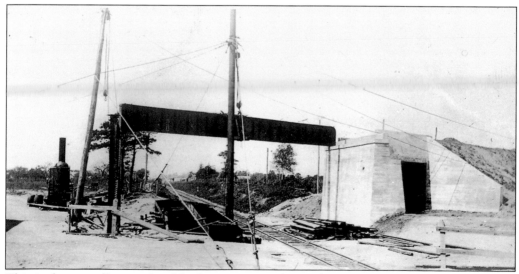

This is the partially completed bridge as seen on September 8, 1908. The view is to the east with Central Avenue to the left of the tracks. A pedestrian walkway can be seen on the right. (Courtesy of the Garden City Archives.)

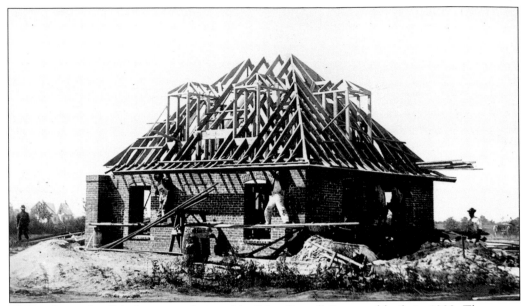

Three identical toll lodges were designed by John Russell Pope and built in 1908. They were two-story buildings, sturdily constructed of brick. Besides serving as toll-collecting stations, the lodges were also the homes of the toll collectors and their families. (Courtesy of the Handley Collection at the Smithtown Library.)

Nearing completion in September 1908 is the Bethpage Lodge. It was located on the northwest corner of Round Swamp Road and survived until the 1960s. Beyond the car, a bridge over Round Swamp Road would be built in 1910. (Courtesy of the Garden City Archives.)

Four

OPENING DAY

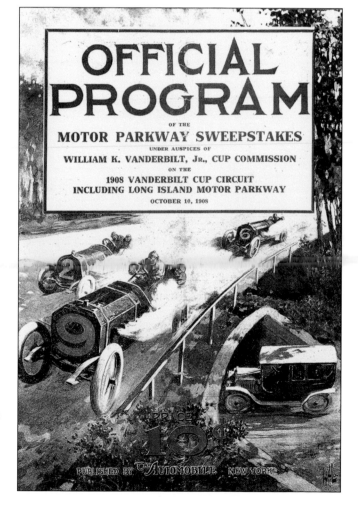

In September 1908, the AAA Race Commission decided to christen the first completed section of the Long Island Motor Parkway with five races. The sweepstakes, which ran concurrently, were scheduled for October 10, 1908. As described in the official program, these contests would provide an opportunity to test the new parkway course, timing systems, and crowd control for the Vanderbilt Cup Race, which was scheduled two weeks after the sweepstakes. The program cover cleverly highlighted one of the main features of the parkway, the elimination of grade crossings.

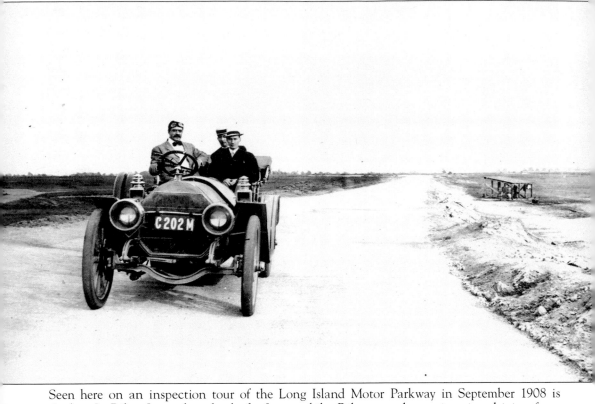

Seen here on an inspection tour of the Long Island Motor Parkway in September 1908 is Andrew L. Riker Jr. at the wheel of a Locomobile. Riker was the engineering driving force behind the Locomobile Company located in Bridgeport, Connecticut, and would enter two race cars in the 1908 Vanderbilt Cup Race. (Courtesy of the Garden City Archives.)

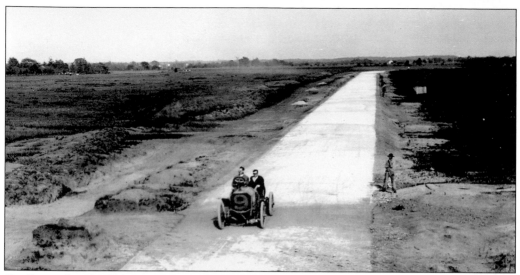

On September 6, 1908, veteran race driver Joe Tracy made several trial runs on the Long Island Motor Parkway in the Locomobile, which finished 10th in the 1906 Vanderbilt Cup Race. Tracy gave the road a positive review: "The cement highway makes an excellent racing road, because it is absolutely dustless, and on account of the grayish color, it does not blind the driver even in the glaring sun, and is very easy to follow even at a terrific speed. Over the straight stretches I think I broke my best record in the last Vanderbilt Cup Race that was about 106 miles per hour for a quarter-of-a-mile stretch." (Courtesy of the National Automotive History Collection at the Detroit Public Library.)

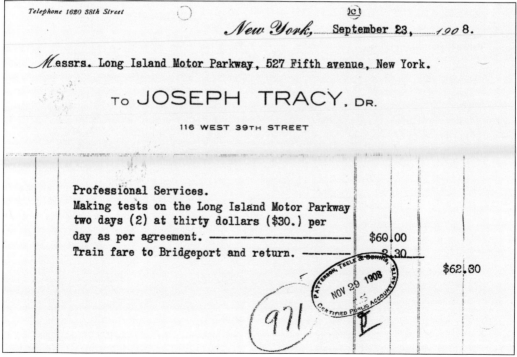

In helping to test the road for the October opening, Tracy was paid a fee of $62 for testing the road over two days. (Courtesy of the Suffolk County Vanderbilt Museum.)

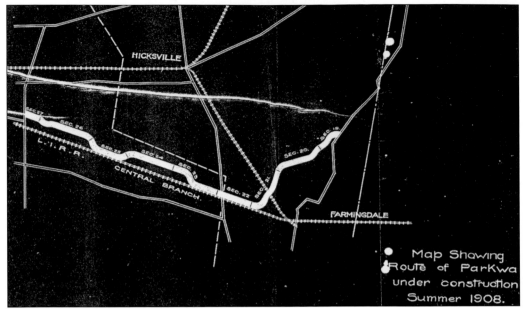

Shown here is a blueprint of the planned completed section of the Long Island Motor Parkway in October 1908. The wide white line depicts the parkway portion of the 1908 Vanderbilt Cup course. A little more than nine miles in length, it stretched from just west of Merrick Avenue in Westbury to Round Swamp Road in Bethpage. This section provided most of the curves on the circuit and also elevation changes created by the bridges under and over the parkway.

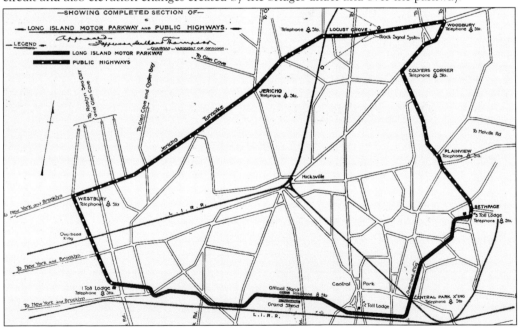

The 1908 Vanderbilt Cup racecourse is shown as printed in the official program. The nine-mile section of the parkway is the solid black portion at the bottom and the short vertical section on the right. The remainder of the course was 14.46 miles of public roads, primarily Round Swamp Road, Plainview Road, Jericho Turnpike, and Ellison Road. (Courtesy of the Suffolk County Vanderbilt Museum.)

46

Long Island
Motor Parkway Opening

OCTOBER 10th, 1908
Race Starts at 9 A. M.

ENTRY BLANK

For

MOTOR PARKWAY SWEEPSTAKES

Under the Auspices of the

WILLIAM K. VANDERBILT, Jr., CUP COMMISSION

On the

1908 Vanderbilt Cup Circuit

Including the LONG ISLAND MOTOR PARKWAY

Five Events. Selling Price Classes.
$5000.00 in Prizes, Cash or Plate.

Under the rules and with the sanction of the
AMERICAN AUTOMOBILE ASSOCIATION.

JEFFERSON DeMONT THOMPSON, Chairman, 437 Fifth Avenue, New York.

Even though it is announced that the Long Island Motor Parkway opened for business on October 10, 1908, there are no indications that festivities were held in conjunction with that long-awaited day. The occasion was simply rolled into and made part of the sweepstakes races held that day. (Courtesy of the Suffolk County Vanderbilt Museum.)

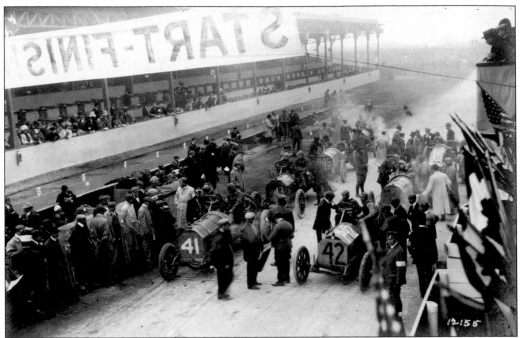

Starter Fred Wagner aligns the 32 race cars for the sweepstakes races in rows of two in front of the grandstand on the south side of the Long Island Motor Parkway, the site located today between Crocus Lane and Skimmer Lane in Levittown. (Courtesy of the Suffolk County Vanderbilt Museum.)

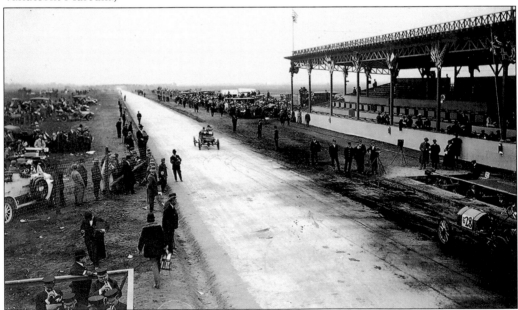

In conjunction with the building of the Long Island Motor Parkway, a grandstand was constructed for the Vanderbilt Cup Races. With a capacity of 5,000 spectators, the structure loomed large over the flat Hempstead Plains, visible for miles. At the start of the sweepstakes races, a band played music to a less-than-filled grandstand. (Courtesy of the National Automotive History Collection, Detroit Public Library.)

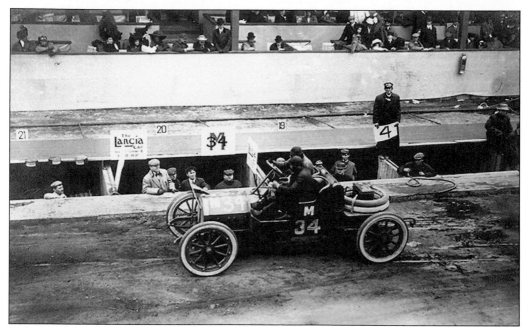

In front of the grandstand, a 300-foot-long supply station pit was built to service the cars. Each pit was five feet deep and stocked with tools, tires, fuel, oil, water, and other supplies to keep each car running smoothly during the race. (Courtesy of the Suffolk County Vanderbilt Museum.)

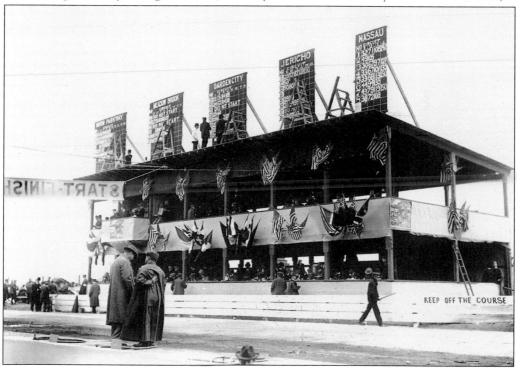

Race officials met in front of the newly built double-decker press and officials' stand located opposite the grandstand. Scoreboards on top of the stand kept track of the five races. (Courtesy of the National Automotive History Collection, Detroit Public Library.)

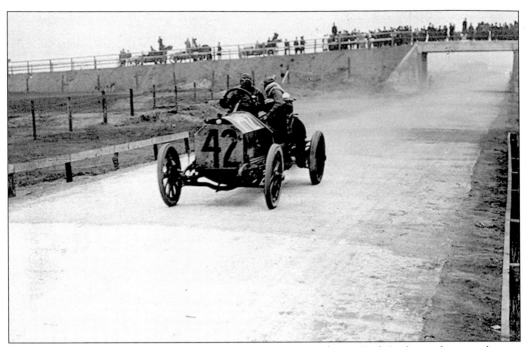

During the Long Island Motor Parkway Sweepstakes Race, driver Herb Lytle can be seen driving his Italian Isotta past the Jerusalem Avenue Bridge. His mechanician is looking over his shoulder, checking for the nearest competitor. (Courtesy of the Suffolk County Vanderbilt Museum.)

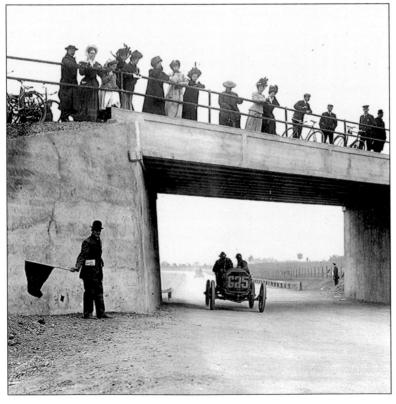

Spectators on the Bloomingdale Road Bridge in the Hempstead Plains are watching the G25 Stoddard-Dayton compete in the Garden City Sweepstakes. Note the two flag officials, one on either side of the bridge. (Courtesy of the National Automotive History Collection at the Detroit Public Library.)

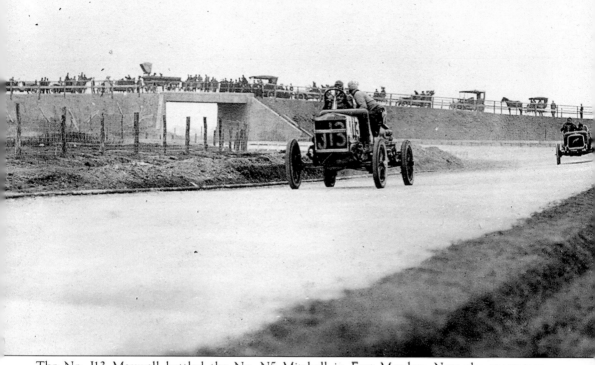

The No. J13 Maxwell battled the No. N5 Mitchell in East Meadow. Note the spectators, automobiles, and horse-drawn carriages atop the Carman Avenue Bridge. (Courtesy of the Suffolk County Vanderbilt Museum.)

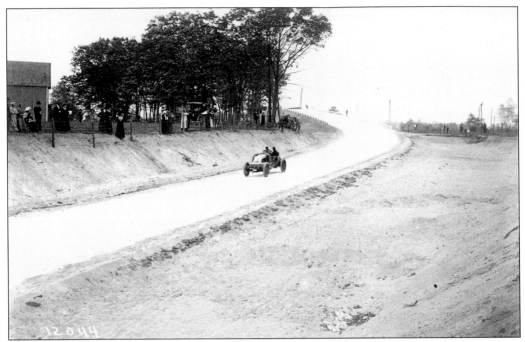

Spectators at this Central Park (Bethpage) location had an excellent view of the cars racing on the Long Island Motor Parkway portion of the race circuit. The race car has just gone over the parkway bridge spanning Central Avenue and the Long Island Rail Road. (Courtesy of the Suffolk County Vanderbilt Museum.)

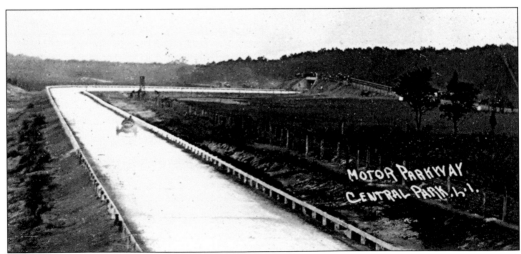

The Long Island Motor Parkway section shown is approximately a half mile north of Powell Avenue in Bethpage. In the distance on the right, the parkway goes under the Plainview Road Bridge, now part of Bethpage State Park, site of the 2002 and 2009 U.S. Open.

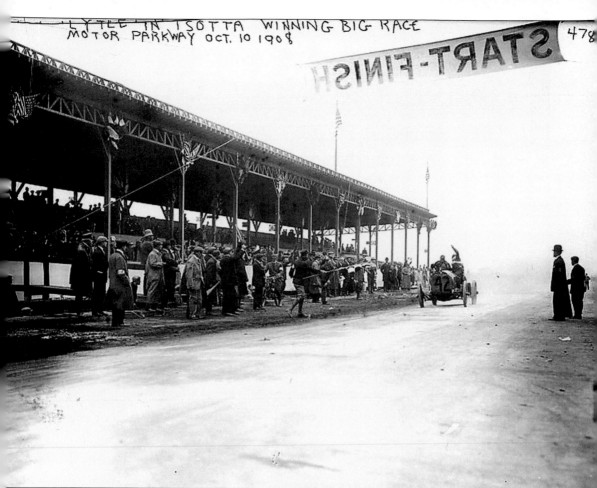

The overall winner of the Long Island Motor Parkway Sweepstake Races was Herb Lytle driving his Italian No. P42 Isotta at an average speed of 64.25 miles per hour, an American driving record for long-distance speed contests. (Courtesy of the Suffolk County Vanderbilt Museum.)

Motor Parkway Open!!

Daily Admission | Pleasure Automobiles $2.00
8 a.m. to 6 p.m. | Motor Bicycles 50 Cents

Vanderbilt Cup Race

Admission to Parkway *OCTOBER 24th*, including car and occupants, parking
space of your own choosing (except at Grand Stand)

TEN DOLLARS

Lodges open all night *Friday, October 23rd*, close at 5 o'clock Saturday morning,

NEAREST LODGE—MEADOW BROOK:—Jericho Turnpike to Westbury (Quaker
Meeting House), turn right, cross railroad, cross Old Country Road to Parkway,
(one mile Jericho Turnpike to Lodge).

MASSAPEQUA LODGE:—Jericho Turnpike to Jericho, turn right, through Hicksville,
(Two miles Hicksville to Lodge).

BETHPAGE LODGE:—From Hicksville, turn left, (Central Hotel), Woodbury Road to
Colyer's Corner, turn right, through Plainview and Round Swamp Roads to
Lodge (2 miles Colyer's Corner to Lodge).

Race starts at daylight. Lodges close 5 A. M.
Do not move car until race is over. Do not walk on the Parkway.

TICKETS ON SALE NOW

OFFICES:—Night and Day Bank Building, 527, Fifth Avenue, New York City.
Denton Block, Mineola, L. I.
Meadow Brook Lodge, near Westbury.
Massapequa Lodge, near Hicksville.
Bethpage Lodge, near Farmingdale.

TO GRAND STAND:—Jericho Turnpike to Franklin Avenue, Mineola, follow trolley to
Hempstead, turn left Fulton Street (Bethpage Turnpike), turn left to signs
indicating Grand Stand, on first road east of New Bridge Road.

Long Island Motor Parkway, *Inc.*
A. R. PARDINGTON, General Manager.

During the two weeks leading up to the Vanderbilt Cup Race, few motorists were willing to pay
the $2 fee to ride the nine-mile section. Long Island Motor Parkway officials put together a $10
package that would allow up to four persons in an automobile to ride on the parkway before and
after the race. This fee included admission to the race and a choice parking spot adjacent to the
grandstand. (Courtesy of the Suffolk County Vanderbilt Museum.)

Five

VANDERBILT CUP RACES ON THE PARKWAY

OFFICIAL PROGRAM

AND

SCORE CARD

FOR THE

VANDERBILT CUP RACE

ON THE

LONG ISLAND MOTOR PARKWAY

OCTOBER 24th, 1908

PRICE 25¢

SOLE OFFICIAL AND AUTHORIZED PROGRAM

Published by The AUTOMOBILE NEW YORK
for the W. K. Vanderbilt, Jr., Cup Commission

By late September 1908, the circuit for the 1908 Vanderbilt Cup Race was finalized and consisted of the same course as the Long Island Motor Parkway Sweepstakes, only nine miles of the Long Island Motor Parkway and 14.46 miles of public highways. The race would be made up of 11 laps for a total of 258.06 miles. The official program featured an illustration of a speeding racer that was also used in posters promoting the race.

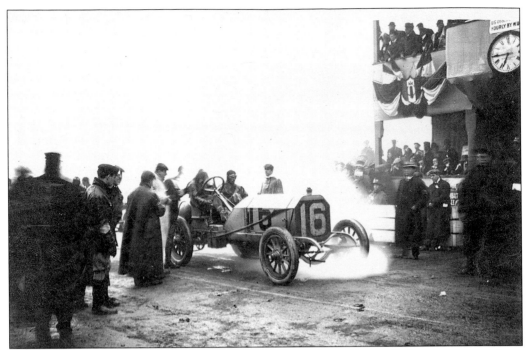

At the starting line of the 1908 Vanderbilt Cup Race, driver George Robertson gets ready to start the No. 16 Locomobile. William K. Vanderbilt Jr. (left, wearing a racing cap and leather jacket) can be seen serving as the race referee.

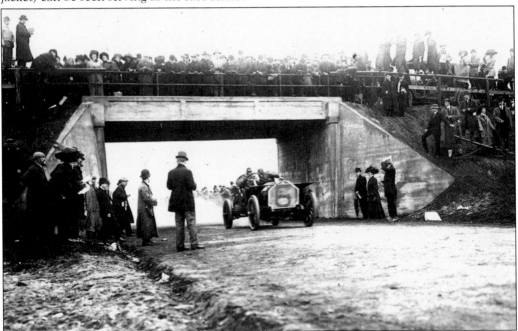

During the 1908 Vanderbilt Cup Race, spectators on the Jerusalem Avenue Bridge watched Herb Lytle's Italian Isotta challenge for the lead. Lytle put up a game fight in this stock car, finishing second. This was the same Isotta that Lytle drove to victory in the Motor Parkway Sweepstakes. (Courtesy of the National Automotive History Collection, Detroit Public Library.)

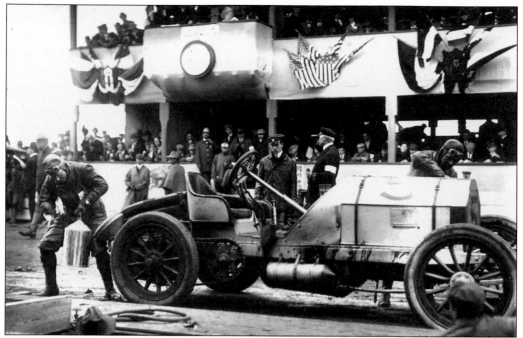

Driver William Luttgen refuels the No. 5 Mercedes as referee Vanderbilt watches in 1908. William K. Vanderbilt Jr. was also the owner of this car. (Courtesy of Brown Brothers.)

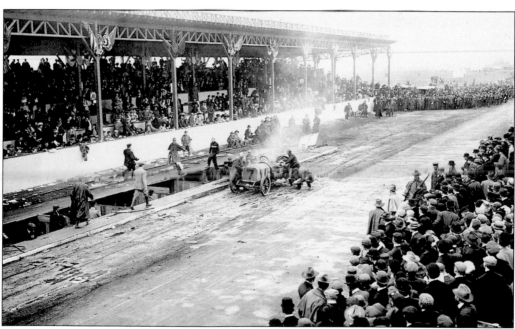

James Ryall's No. 7 Matheson retired from the race in spectacular fashion. At the end of lap 4, he slowed his smoking racer and gave grandstand spectators a thrill when flames leapt from under the engine cowling. A flaw in design had placed the carburetor too close to the red-hot exhaust, and fuel splashed out of it when he shot over Newbridge Road Bridge at full speed. The errant fuel ignited and was extinguished at the grandstand pits.

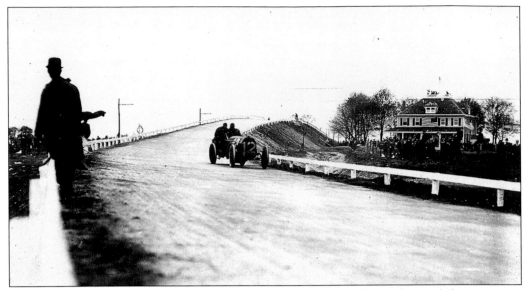

George Salzman in the No. 12 Thomas was going about 65 miles per hour while navigating the Motor Parkway's Newbridge Road Bridge in the Hempstead Plains, in today's Levittown. Spectators watched from the roof of the Newbridge Hotel, which was covered with American flags to celebrate the race.

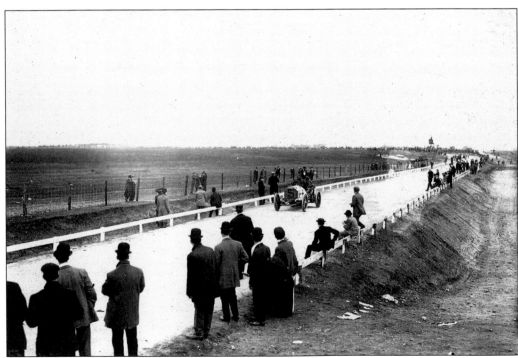

The No. 5 Mercedes driven by William Luttgen pulled to third place during lap 10 after making the curve past the Jerusalem Avenue Bridge. (Courtesy of the National Automotive History Collection, Detroit Public Library.)

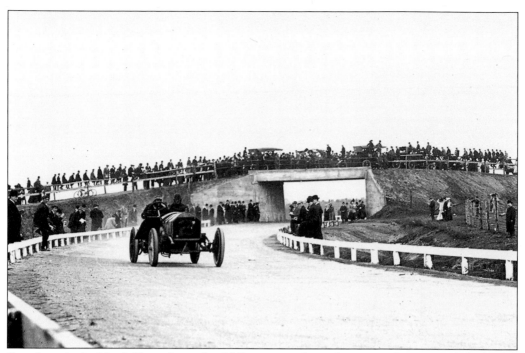

Seen here is the No. 2 Knox driven by Al Denison making the curve after it passed the bridge south of Bloomingdale Road. (Courtesy of the National Automotive History Collection, Detroit Public Library.)

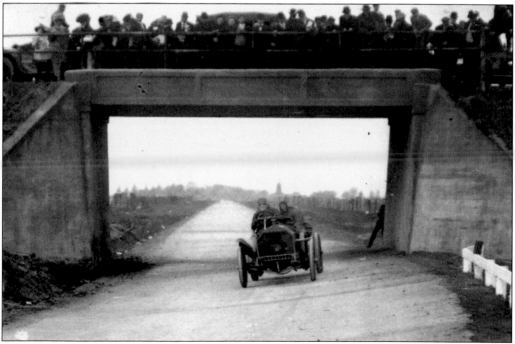

Running second, Emil Stricker drove the No. 3 Mercedes under the Carman Avenue Bridge in East Meadow during lap 5. However, a broken fan blade gashed the radiator, and the engine overheated on lap 10. Stricker was awarded a sixth-place finish. (Courtesy of the Henry Ford.)

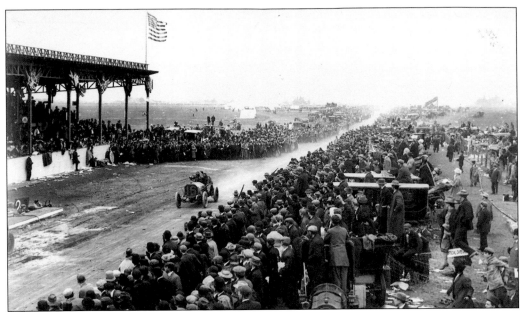

With a lead of over four minutes, George Robertson's Locomobile began the final lap of the race apparently on his way to an easy victory. However, instead of taking a conservative pace, Robertson pushed so hard he lost control and skidded backward off Plainview Road and destroyed one of his tires. Amazingly, the car was otherwise undamaged. Robertson's place in history hinged on his skills and those of his riding mechanician Glenn Ethridge in changing the tire. In a swift 2 minutes and 10 seconds, a new tire was mounted on the rim. (Courtesy of Brown Brothers.)

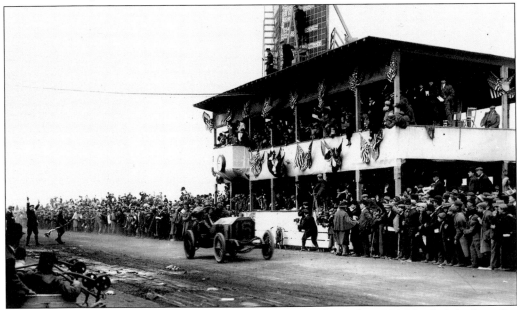

Robertson drove the big Locomobile across the line to claim the 1908 Vanderbilt Cup. For the first time, America could finally boast victory in an automobile race against international competition. Robertson averaged 64.3 miles per hour and finished 1 minute and 48.2 seconds ahead of Herb Lytle's Isotta. (Courtesy of Brown Brothers.)

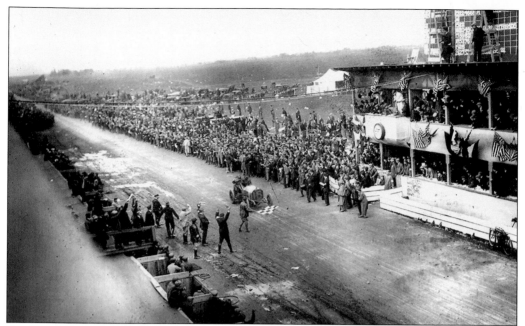

Brash and daring, 23-year-old George Robertson took the checkered flag from starter Fred Wagner before a huge crowd at the grandstand. Jefferson De Mont Thompson (center), chairman of the race commission, can be seen with his hands raised. Beside him to his left was the ever-vigilant referee William K. Vanderbilt Jr. Now called "Old 16," the car is currently displayed at the Henry Ford Museum in Dearborn, Michigan. (Courtesy of Brown Brothers.)

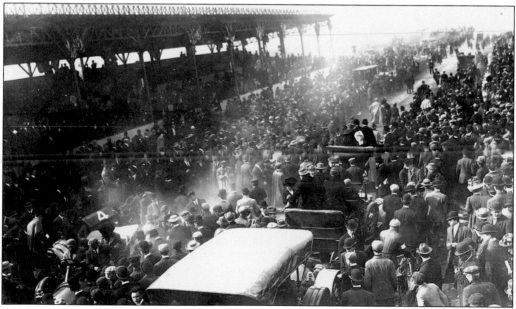

The scene was pandemonium after Robertson won the 1908 race. Typical of crowds immediately following the declaration of a winner, people swarmed the road to head home or surround the winning car. The race was officially called off at 10:55 a.m., and telephone calls went out to signalmen to display white danger flags to waive off the remaining nine cars still on the course. (Courtesy of the National Automotive History Collection, Detroit Public Library.)

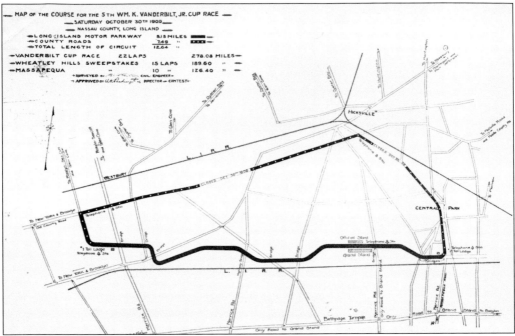

At 12.64 miles, the 1909 course was shorter than those for any previous Vanderbilt Cup Race and for the first time did not cross railroad tracks. The Long Island Motor Parkway made up 5.15 miles of the total distance. Organizers believed the shorter course would decrease the intervals of time between appearances of cars and also provide more exciting entertainment for spectators.

Official Score Card and Guide

OF THE

Fifth Competition for the Wm. K. Vanderbilt, Jr., Cup

HELD ON THE

LONG ISLAND MOTOR PARKWAY and Country Road System

NASSAU COUNTY, LONG ISLAND

Saturday, October 30th, 1909, starting at 9 a. m.

Under the auspices of the Motor Cups Holding Company
With the sanction and under the rules of the American Automobile Association

MOTOR CUPS HOLDING COMPANY

Sole Official and Authorized Program Published by White & Schemm for the Motor Cups Holding Co.

The Long Island Motor Parkway was an attraction for the Vanderbilt Cup Races held from 1908 to 1910, as shown in the official scorecard and guide.

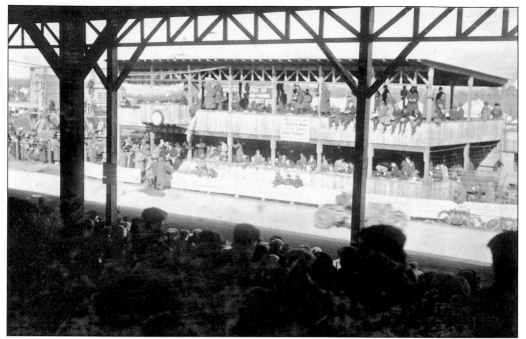

Grandstand spectators had an excellent view of the action that was taking place on the Long Island Motor Parkway. Across the road was the two-level press and officials' stand, which served as a hub for the event. (Courtesy of the National Automotive History Collection, Detroit Public Library.)

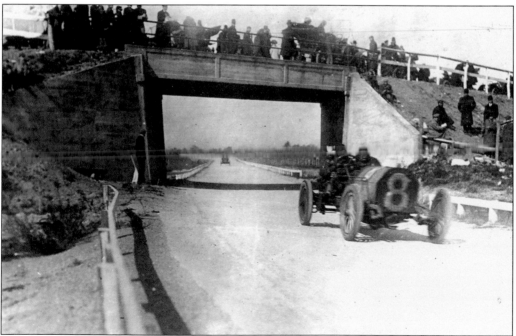

Harry Grant's No. 8 ALCO moved into second place as he passed under the bridge south of Bloomingdale Road during the 1909 race. This area is now filled with Levittown homes. (Courtesy of the National Automotive History Collection, Detroit Public Library.)

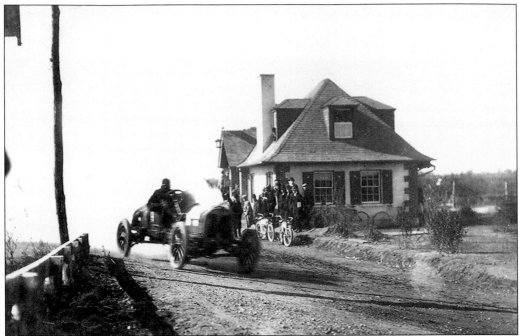

The No. 14 Fiat driven by Edward Parker leaves the Long Island Motor Parkway section of the 1909 course. The Massapequa Lodge can be seen in the background. Parker would finish second in the race. (Courtesy of the National Automotive History Collection, Detroit Public Library.)

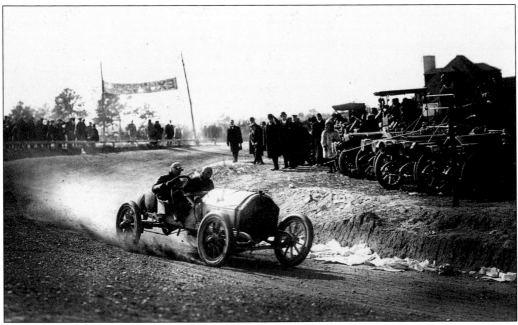

The No. 7 Chalmers-Detroit, driven by William Knipper, skidded through the Massapequa turn. The banked turn was part of a temporary road built especially for the race to connect the exit of the Long Island Motor Parkway with northward-bound Massapequa-Hicksville Road. (Courtesy of Brown Brothers.)

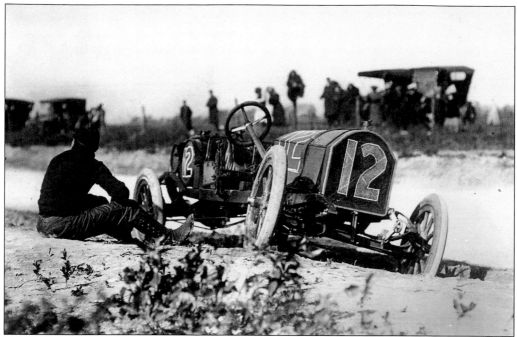

Disappointed driver Harry Stillman sat beside his disabled No. 12 Marmon racer when his radiator cracked during lap 7 on the parkway. (Courtesy of the National Automotive History Collection, Detroit Public Library.)

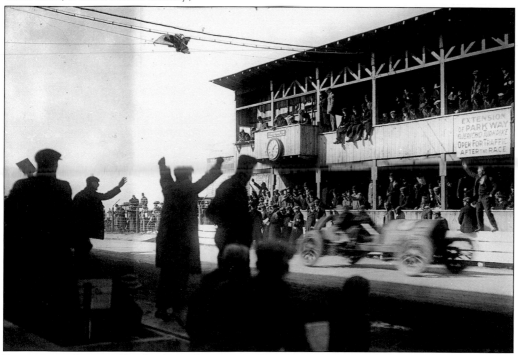

Pit crews and race officials cheered as Harry Grant's ALCO passed the finish line and won the 1909 Vanderbilt Cup. Note the sign on the right side of the officials' stand announcing the extension of the parkway to Jericho Turnpike. (Courtesy of Helck family collection.)

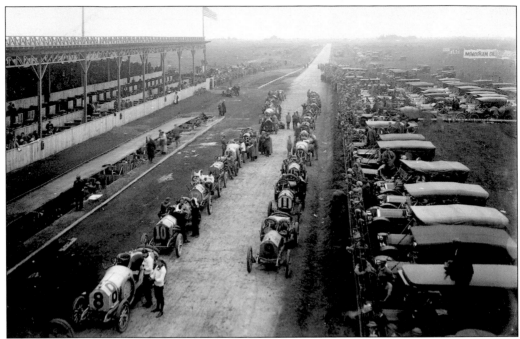

The 1910 Vanderbilt Cup Race was run on the same course used in 1909. This view was from atop the double-decker press and officials' stand where a bugler blew horn blasts as cars came into view. Starter Fred Wagner lined up odd-numbered cars to the inside of the course and even-numbered cars to the outside. A row of spectator cars was parked north of the Long Island Motor Parkway at the start of the race. These were prized parking spots as many people viewed the race from their cars. (Courtesy of the George Eastman House.)

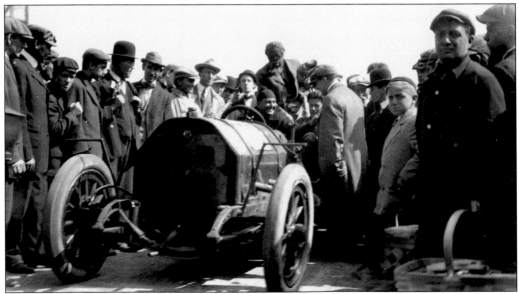

Driver Harry Grant (center) and his mechanician Frank Lee (right) posed with admirers after taking the Vanderbilt Cup Race for the second consecutive year. Grant used the same ALCO—certified by officials after the race as a stock car—in both his victories. (Courtesy of the George Eastman House.)

Six

QUEENS COUNTY

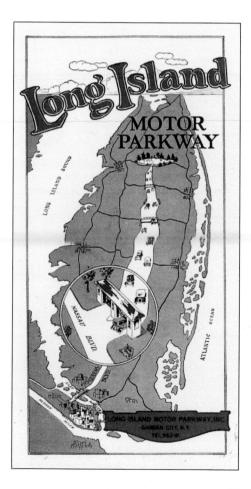

In the 1920s, the parkway benefited as the automobile became more commonplace in the lives of the ordinary American. As an accommodation to the ever-growing number of motorists, the Long Island Motor Parkway was extended approximately three miles farther west in 1926. The final terminus was at Nassau Boulevard (renamed Horace Harding Boulevard) in Fresh Meadows. The total length of the parkway from Queens to Lake Ronkonkoma including the Commack Spur Road was 47.2 miles. This rare 1928 brochure promoted the new entrance at Fresh Meadows. Note the tollgate spanning the road. (Courtesy of Robert Harrington.)

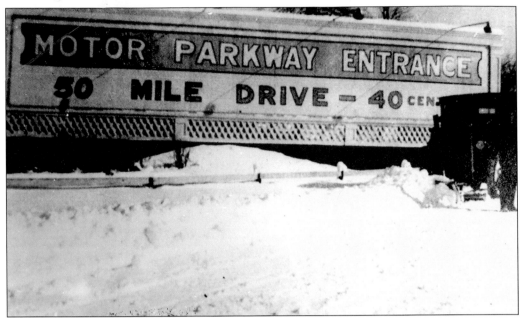

This sign was erected on Horace Harding Boulevard, today's service road for the Long Island Expressway. In the late 1930s, when the toll fee was reduced to 40¢, the hard-to-miss billboard, measuring approximately 6 by 30 feet, was placed just west of the parkway entrance. At 50 miles, the parkway took large round-off liberties over the actual length. (Courtesy of the Historical Society of the Westburys.)

The first Long Island Motor Parkway bridge after the western terminus was over North Hempstead Turnpike in Fresh Meadows, Queens. Identical to the other remaining bridges in Queens, it was demolished in the late 1950s, when the area was developed as part of Cunningham Park. This is one of the few known images of the bridge. (Courtesy of Mitch Kaften and Douglas I. Kaften.)

This is an aerial view of the Long Island Motor Parkway at Fresh Meadows in Queens with a view to the west. The major roadway left of center is Union Turnpike. The parkway is the parallel road to the right indicated by the arrows. The 1939 photograph shows the parkway with a 90-degree curve taking the road on a northerly course, once again indicated by the arrows. (Courtesy of the UCLA Department of Geography, Benjamin and Gladys Thomas Air Photo Archives, the Fairchild Collection.)

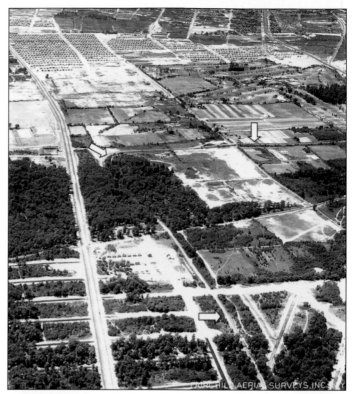

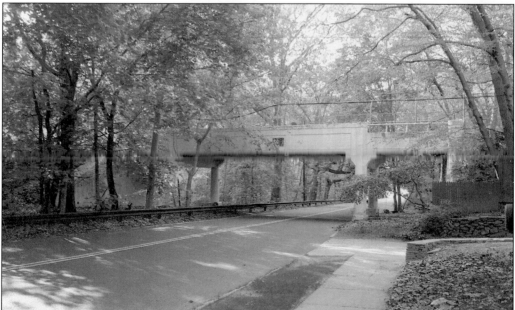

Seen here in this 2008 photograph is the Hollis Hills Terrace Motor Parkway Bridge. Constructed of concrete, it is one of four identical bridges erected in the late 1920s, when the parkway was extended westward. The surviving portion of the parkway in Queens is no longer used for automobiles but is part of a walking, jogging, and bicycling path connecting Cunningham and Alley Pond Parks.

Shown here is a 1930s aerial view of the Hollis Hills section of Queens looking east. The Motor Parkway is seen on the left side with the bridge over Hollis Hills Terrace on the lower left corner. Union Turnpike can be seen on the right and the Grand Central Parkway on the top right corner. (Courtesy of the UCLA Department of Geography, Benjamin and Gladys Thomas Air Photo Archives, the Fairchild Collection.)

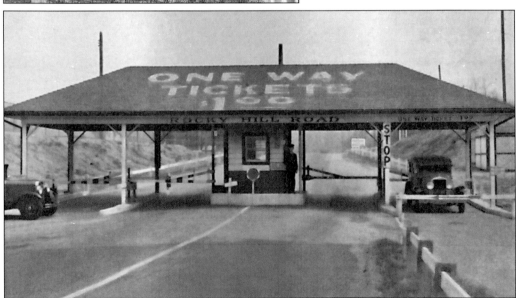

The Rocky Hill Road Toll Booth officially opened on July 1, 1928. It was located approximately 600 feet east of present-day Springfield Boulevard in Queens. Although the toll receipt said "Rocky Hill Road Lodge," it clearly was a tollbooth only, very similar to those still in use today. Standing outside on the right side of the booth is Sidney A. Jones, who would man this location until the parkway closed in 1938.

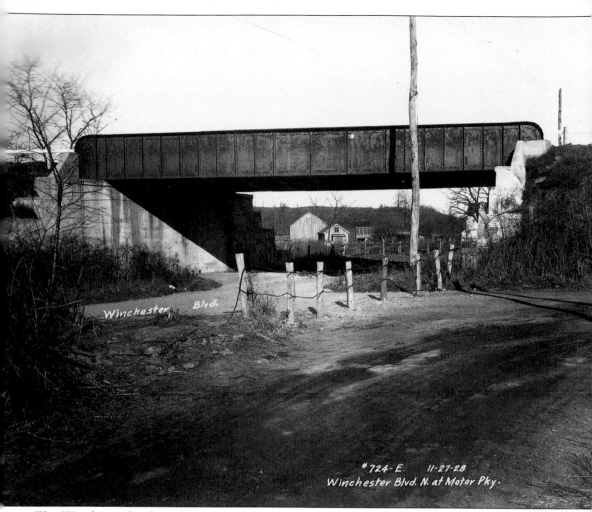

Winchester Blvd.

#724-E 11-27-28
Winchester Blvd. N. at Motor Pky.

The Winchester Boulevard Motor Parkway Bridge was built in 1912. At that time, New York City required the parkway corporation to use railroad-type trestle construction over the public roads. Looking north, a portion of the Creed Farm can be seen underneath the bridge. The farm would later become part of Alley Pond Park.

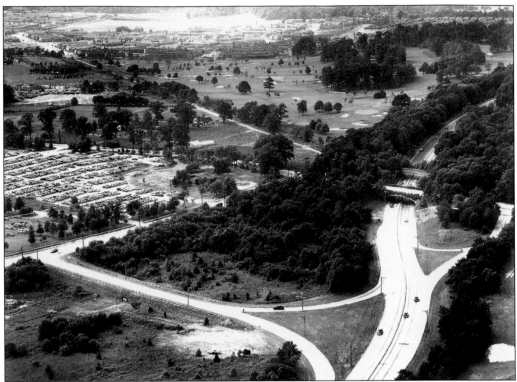

The Long Island Motor Parkway bridge over the Northern State Parkway at Lake Success can be seen in the upper right corner of this photograph looking west. The parkway enters the scene from the top left-hand corner, angling down to the center of the photograph, and crossing over the Northern State Parkway. The more prominent bridge is over Lakeville Road. (Courtesy of the UCLA Department of Geography, Benjamin and Gladys Thomas Air Photo Archives, the Fairchild Collection.)

A newspaper advertisement promoted the Long Island Motor Parkway, noting "Easy Accessibility to State Parks, Beaches, Golf Courses, Aviation Fields and Lake Ronkonkoma." (Courtesy of the Suffolk County Vanderbilt Museum.)

Seven

NASSAU COUNTY

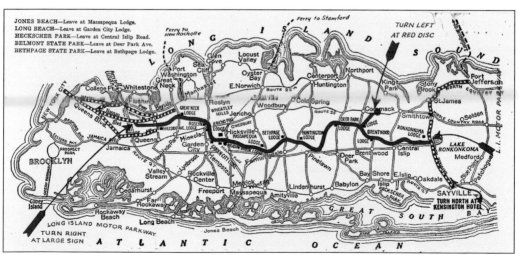

A 1929 map published by the Long Island Motor Parkway indicated the lodges, entrances, and connecting roads. These maps were distributed to automobile club members and parkway users and identified all entrances with a lodge designation. That year there were 14 authorized entrances to the parkway, only 9 of which had living accommodations for the toll collectors and their families.

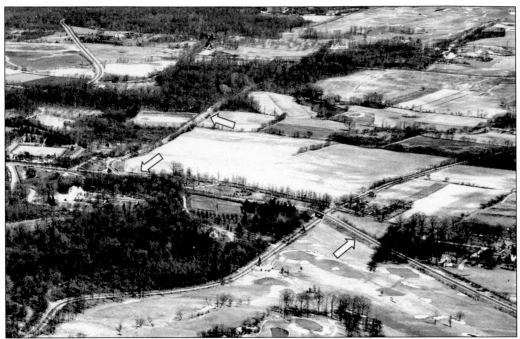

This 1929 photograph is of the Lake Success area in Nassau County. The view is to the northeast. The golf course in the foreground is the old Glen Oaks Country Club, today the home of the North Shore Towers complex. The Long Island Motor Parkway can be seen entering from the right, just below the centerline angling northward and abutting the golf course. It crosses over Marcus Avenue, paralleling Lakeville Road for a short distance before crossing over that road barely observable in this image. Deepdale, the former home of William K. Vanderbilt Jr., can be seen in the lower left section of the photograph. (Courtesy of the Suffolk County Vanderbilt Museum.)

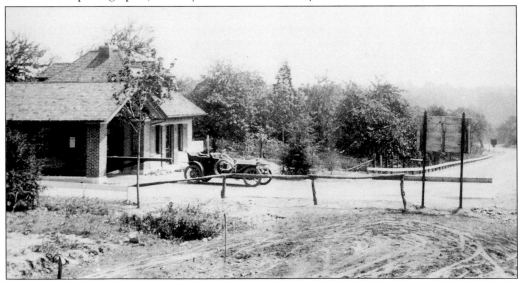

The Great Neck Lodge at Lake Success is shown in 1910 looking east. The photograph was taken to commemorate the opening of the new western terminus of the parkway. Note the barricade blocking access to the westerly portion, which was under construction. (Courtesy of Virginia MacMurray.)

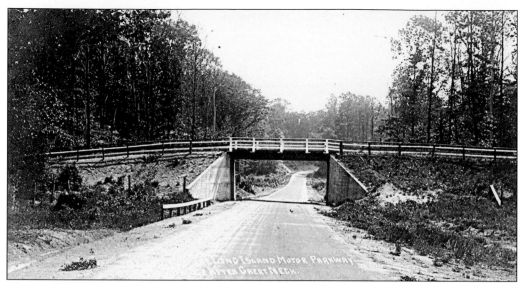

This is the parkway bridge over New Hyde Park Road. Erected in 1910, it was typical of the bridges built over public roads. A portion of the bridge's embankment on the east side of the road still stands today.

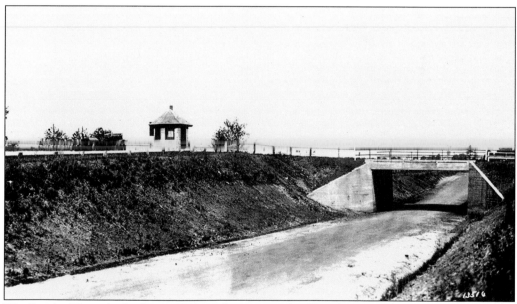

The Jericho Turnpike Lodge in 1911 can be seen south of Jericho Turnpike in Mineola and west of the Long Island Motor Parkway. At this point, the parkway went under Jericho Turnpike. Although designated as a lodge, the initial toll-collecting station at this location was a ticket booth only. The Mineola Lodge would be built later, 200 feet south of the station's location. (Courtesy of the Suffolk County Vanderbilt Museum.)

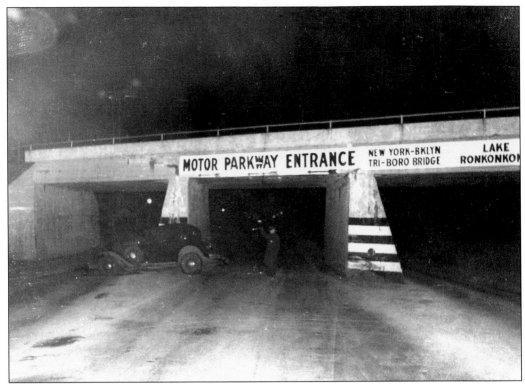

This is the Clinton Road Bridge in Garden City. This scene records an accident, which was fairly common at this location. Motorists preferred to use the center opening of the roadway, as the outer openings were not paved. There were only two bridges with three openings in Nassau County; the other was over Westbury Avenue in Mineola. (Courtesy of Ron Ridolph.)

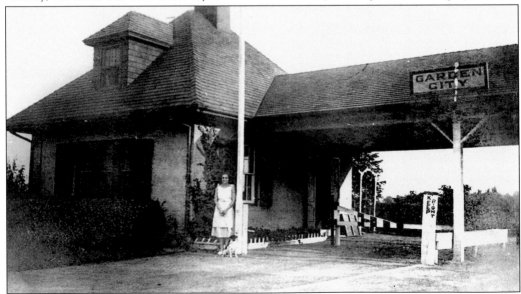

Elizabeth Ernst, wife of the toll collector, is shown outside the Garden City Lodge about 1935. The Ernsts purchased the lodge when the Long Island Motor Parkway closed in April 1938, and it was their home until the late 1970s. (Courtesy of Walter McCarthy.)

Alfred J. Kienzle (left) was the parkway's general manager from 1911 to 1938. Arthur G. Archibald (right) was the parkway's engineer from 1927 to 1938. The men are standing in front of the first Garden City office located east of Clinton Road on the south side of the Long Island Motor Parkway right-of-way. The building was in use from 1915 to mid-1929. (Courtesy of Virginia MacMurray.)

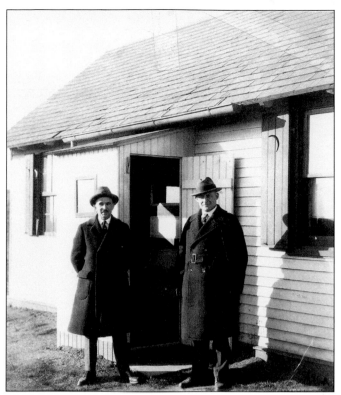

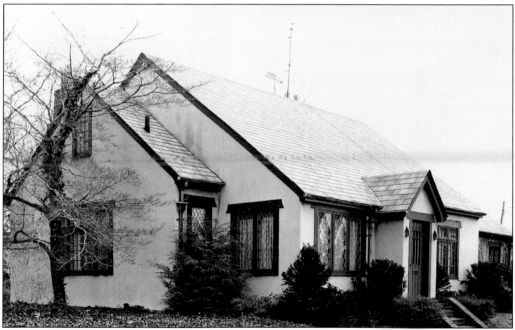

Seen here is the Long Island Motor Parkway office at Garden City. This building replaced the initial Garden City office in 1929. The attractive, well-styled structure was built from store-bought plans slightly modified by Archibald. The building still exists today and has been basically untouched as a residence since 1939.

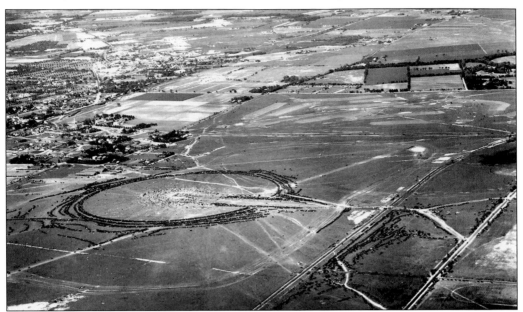

One of the busiest days on the Long Island Motor Parkway was June 16, 1927, when Charles Lindbergh returned to Roosevelt Field to celebrate his successful solo flight to Paris. Lindbergh had taken off from the Roosevelt Field east runway 27 days earlier. The parkway is the road in the middle of the image running parallel to Stewart Avenue on the right. The circle in the photograph was formed by rows and rows of automobiles surrounding the dedication area. Stewart Avenue was a major access point that day with traffic using the bridge over the parkway to reach the ceremonies. In the same location today, the Merchants Concourse Bridge takes shoppers over the Meadowbrook Parkway.

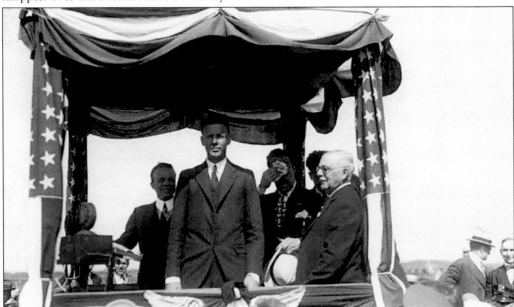

At the homecoming celebration, Col. Charles Lindbergh addressed an estimated crowd of 25,000 people and promoted the development of Roosevelt Field as a major aviation center. Lindbergh had landed his plane *Spirit of St. Louis* at Roosevelt Field earlier in the morning.

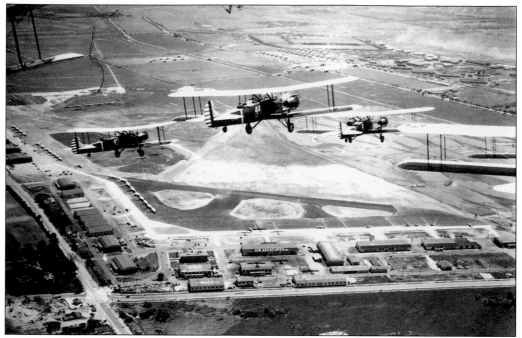

Keystone B-5 bombers fly over Roosevelt Field in 1931. The Long Island Motor Parkway can be seen at the right edge of the top wing of the center bomber. The Keystone B-5s were the frontline bombers for the United States from 1930 to 1934. They remained in service until the early 1940s, serving primarily as observation aircraft. (Courtesy of the Cradle of Aviation Museum.)

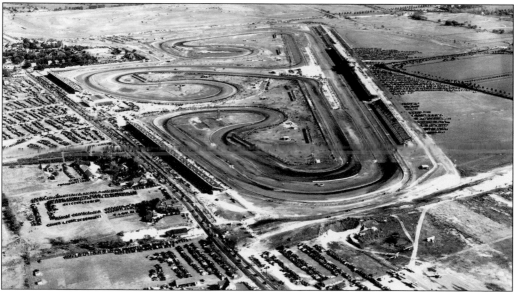

In 1936 and 1937, the Vanderbilt Cup Races were revived under the sponsorship of George Vanderbilt, a nephew of William K. Vanderbilt Jr. Roosevelt Raceway, the site of the races, was built in 1936 in the eastern section of Roosevelt Field with grandstands for over 60,000 spectators. Cars can be seen racing on the multi-curved track on October 10, 1936. The parkway, located at the top right of the photograph, opened a temporary entrance to the raceway, resulting in higher revenue for the struggling toll road.

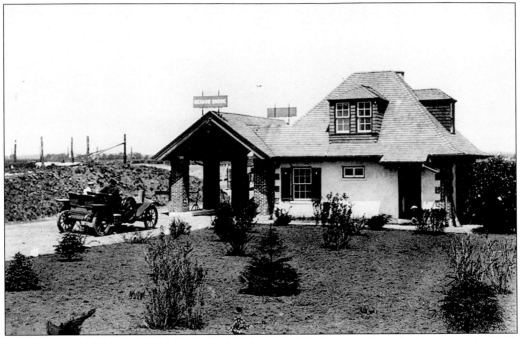

The "No. 1" toll lodge was the Meadow Brook Lodge, just west of Merrick Avenue and today's Eisenhower Park. The two-story lodge had stucco-covered brick walls and steep-pitched shingled roofs with dormers. The interior of each lodge contained a small office, a pleasant kitchen, a large living room with a fireplace, and stairs leading to the two bedrooms on the second floor. (Courtesy of the Suffolk County Vanderbilt Museum.)

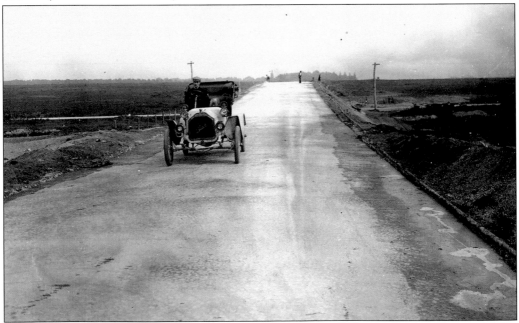

This 1908 photograph shows the Long Island Motor Parkway west of Merrick Avenue. The photographer, standing at the base of the Merrick Avenue Bridge, has positioned his automobile north of the Meadow Brook Lodge. (Courtesy of the Garden City Archives.)

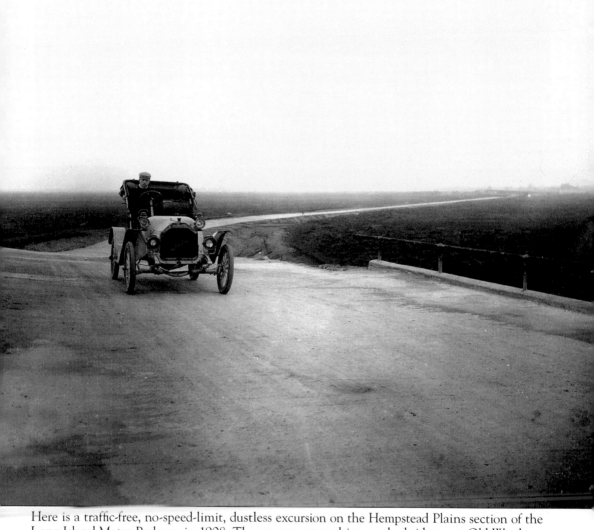

Here is a traffic-free, no-speed-limit, dustless excursion on the Hempstead Plains section of the Long Island Motor Parkway in 1908. The car was set to drive on the bridge over Old Westbury Road. (Courtesy of the Garden City Archives.)

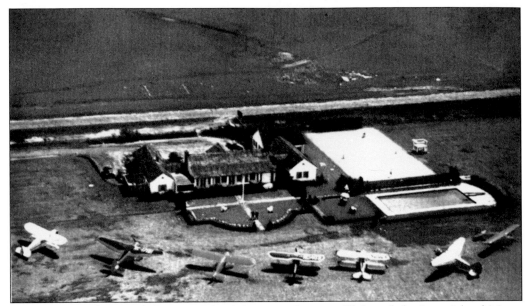

This is an aerial view of the Long Island Aviation Country Club and the Long Island Motor Parkway. The club was formed in June 1929 by an elite group of flyers with Charles Lindbergh as a charter member. The flying field was located to the west of Jerusalem Avenue in today's Levittown with the parkway being the southern boundary.

Shown here in the 1930s is a gathering of flying enthusiasts at the Long Island Aviation Country Club. Among the members was William K. Vanderbilt Jr. The club requested permission to open an entrance to the adjacent parkway. To their surprise and dismay, Vanderbilt refused, not wanting to set a precedent.

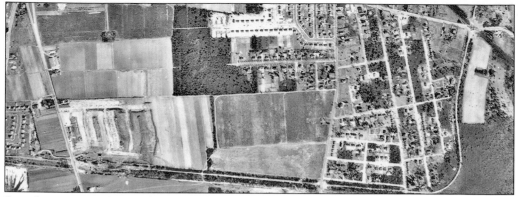

Seen here in a 1950 aerial view is the mostly rural Bethpage area. The vertical roadway on the left is Massapequa-Hicksville Road. The Long Island Motor Parkway enters the scene in the bottom left hand corner, proceeding eastward along the bottom of the photograph. It crosses over Stewart Avenue, right of center. Just past North Hermann Avenue, the parkway turns to the north. The 90-degree turn is often described as one of the "Deadman's Curves" of the parkway. At the top right-hand corner, the parkway crossed over the intersecting Central Avenue and the Long Island Rail Road.

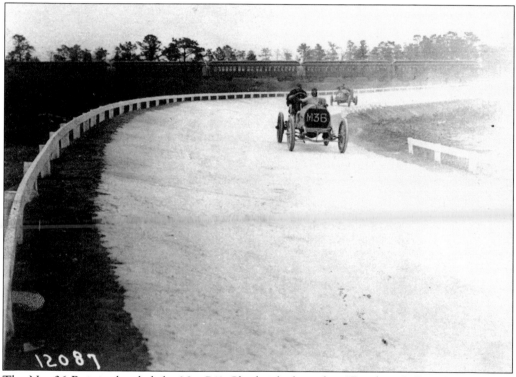

The No. 36 Rainier battled the No. P41 Chadwick through a "Deadman's Curve" in Central Park, now Bethpage. In the background, a line of race special commuter cars of the Long Island Rail Road on the tracks of the Central Railroad division line can be seen. The Long Island Rail Road would run a number of these specials on race days as many of the spectators came out from the city by railroad. (Courtesy of the Suffolk County Vanderbilt Museum.)

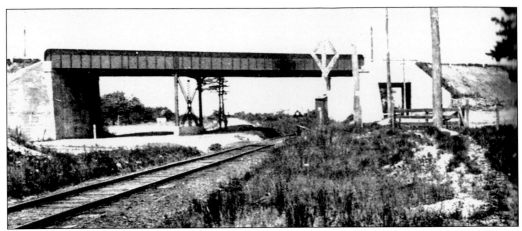

Seen here is the completed Long Island Motor Parkway bridge over the Long Island Rail Road and Central Avenue in Bethpage. The steel trestle construction, rather than concrete, was mandated by the railroad. The same type of bridge was used to span the Oyster Bay line at East Williston and the main line through Mineola. The view is to the east with Central Avenue to the left of the tracks. A pedestrian walkway can be seen on the right.

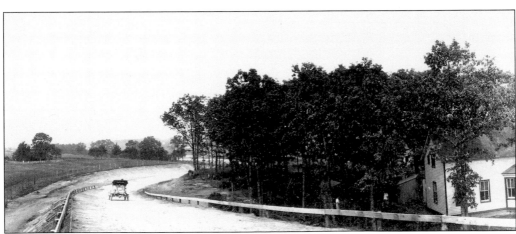

This view shows a northbound motorist after crossing over the Central Avenue Bridge. The fencing on both sides of the roadway was a first in highway construction, instituted by the parkway builders. (Courtesy of the Garden City Archives.)

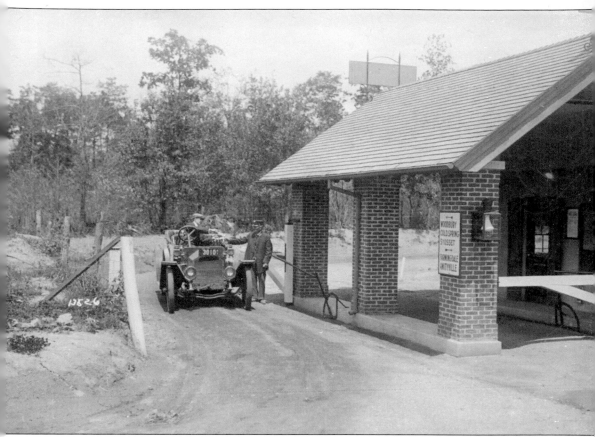

Shown here is a typical transaction between the toll collector and a motorist entering the parkway at the Bethpage Lodge. The toll collector is Thomas Grafenstein, and the motorist is William Evans of New York City. Normally the transaction would have taken place under the porte cochere. As an accommodation for the photographer, Joseph Burt, the scene was shot on the exit lane. (Courtesy of the Suffolk County Vanderbilt Museum.)

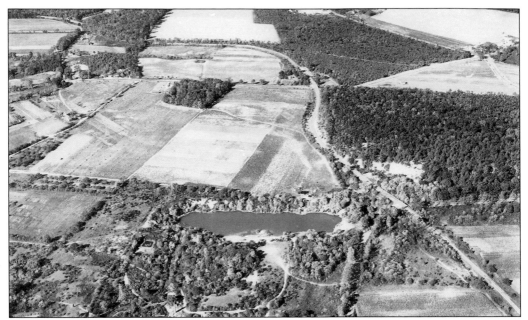

This is a 1935 aerial view of the Old Bethpage area, looking west. The parkway is the only discernible road in the photograph. It enters the scene from the top left-hand corner having just exited today's Bethpage State Park. It then proceeds in a northerly direction before turning to the right (eastward), crossing over Round Swamp Road into the current Battle Row campgrounds. The parkway then enters today's Old Bethpage Restoration Village, the area in the bottom right-hand corner. (Courtesy of the UCLA Department of Geography, Benjamin and Gladys Thomas Air Photo Archives, the Fairchild Collection.)

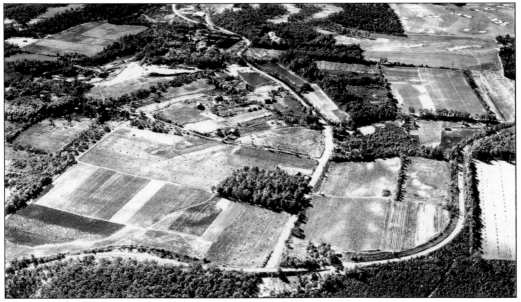

This 1935 aerial is centered on the Bethpage Lodge, located west of Round Swamp Road on the north side of the Long Island Motor Parkway, which is along the bottom of the image. Note the curved section of the Motor Parkway on the bottom right corner. (Courtesy of the UCLA Department of Geography, Benjamin and Gladys Thomas Air Photo Archives, the Fairchild Collection.)

Eight

SUFFOLK COUNTY

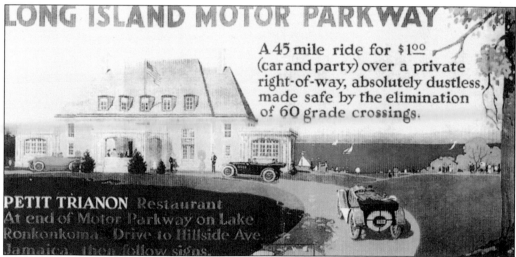

A beautiful poster promoting the parkway was distributed throughout New York City. Note the toll price of $1 on the poster. The price of a round-trip was a measure of the Long Island Motor Parkway's popularity. When it opened in 1908, the toll was $2, the equivalent to $45 today. In 1912, the toll was reduced to $1.50 and five years later dropped to $1, which held steady until 1933. With a dramatic drop in business due to the opening of the free Northern State Parkway, the toll fee was dropped to 40¢. (Courtesy of the Suffolk County Vanderbilt Museum.)

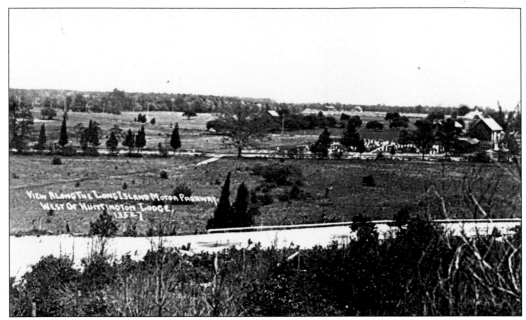

In a 1911 postcard view looking eastward is the Long Island Motor Parkway through the sandpits in the Melville area of Huntington. The highway above and paralleling the parkway is Walt Whitman Road. On the right is the church building and cemetery still in place at the junction of Route 110 and Walt Whitman Road.

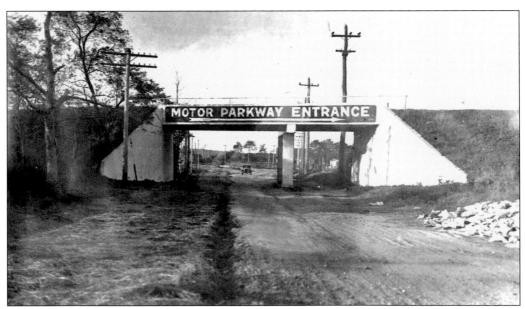

A rare 1935 image of the parkway bridge over Broad Hollow Road in Melville is shown, looking north. The narrow section on the right was built to accommodate the trolley line that once ran between Babylon and Huntington Village and ceased operations in 1927. The sign points to the parkway entrance at the Huntington Lodge. (Courtesy of the Suffolk County Vanderbilt Museum.)

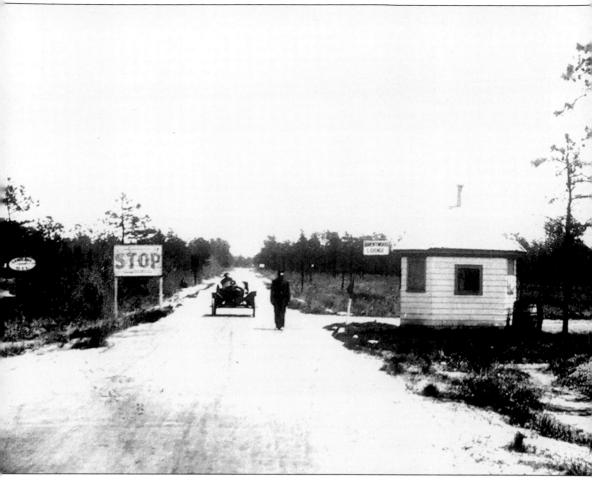

This is the original Brentwood Lodge in 1911, looking east. The first Brentwood Lodge was a ticket booth only, located at the southwest corner of Washington Avenue at Brentwood. The man standing on the unpaved Long Island Motor Parkway right-of-way is Thomas O'Rourke, the toll collector who would man this post for five years. (Courtesy of Virginia MacMurray.)

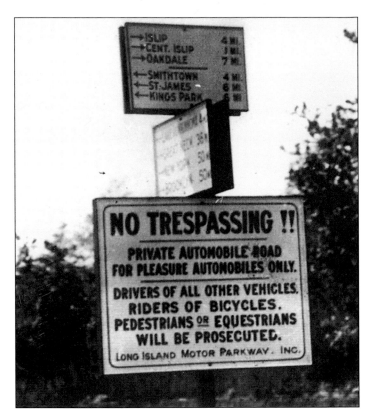

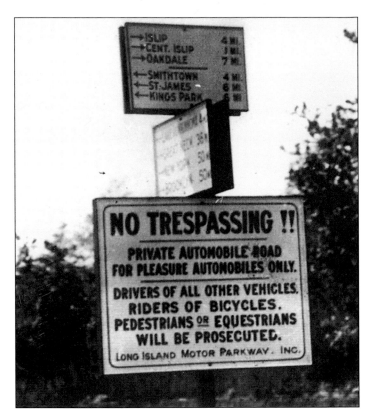

Heading east to Lake Ronkonkoma, the last parkway bridge in Suffolk County went over Deer Park Avenue. Some 20 additional bridges were planned but never built due to lack of funds. Many of the intersections with public roads had "No Trespassing" signs to keep unwanted traffic off the Long Island Motor Parkway. This sign was placed at the Wheeler's Road intersection near Central Islip.

DANGER NOTICE

At the Commack, Central Islip and Ronkonkoma **GRADE CROSSINGS,** motorists must come to a **DEAD STOP.** A large sign marked **"STOP"** will be found 50 feet from each road and a warning sign 300 feet therefrom.

At all other Grade Crossings, indicated on signs, **SPEED** must be **REDUCED** to a **SAFE LIMIT,** in no case more than the **LEGAL LIMIT.**

By order of

LONG ISLAND MOTOR PARKWAY, Inc.

The Long Island Motor Parkway is sometimes described in mythic characteristics. One of the most difficult to correct is that it was free of any intersections. While that was true in Queens and Nassau, there were several intersections in Suffolk, some at major crossroads. The above notice was issued to motorists when entering the parkway. It clearly states they were required to come to a complete stop before proceeding. (Courtesy of the Suffolk County Vanderbilt Museum.)

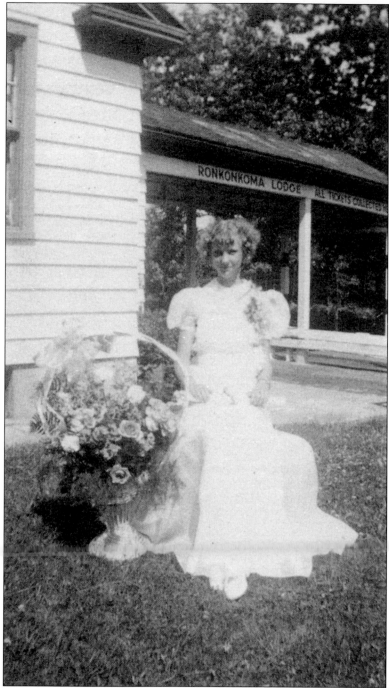

The prettily dressed young lady is Evelyn Ericson, the daughter of Eric Ericson, the Ronkonkoma Lodge gatekeeper. The photograph, taken in the 1920s, shows the porte cohere section of the lodge in the background. Built in 1923, the Ronkonkoma Lodge was on the north side of the parkway approximately 1,500 feet west of Rosevale Avenue. The porte cochere straddled the parkway, which became the style of modern-day tollbooths. (Courtesy of the Suffolk County Vanderbilt Museum.)

The Petit Trianon Restaurant.

The Long Island Motor Parkway, Inc., has arranged with the Hotel Astor, for the management of the Petit Trianon Restaurant, erected by the Parkway, on the shores of Lake Ronkonkoma, at the easterly end of the Parkway.

The restaurant will be open for dinner to those receiving this notice, on Friday evening, June 9th 1911 (the day previous to its opening to the public), and you are cordially invited to be present on that evening.

Applications for tables should be made by telephone or letter to the restaurant.

When the route to Lake Ronkonkoma was completed in 1911, parkway officials decided to build a high-class dining facility and halfway stop for travelers. On June 9, 1911, William K. Vanderbilt Jr. held a special dinner reception at the inn the night before its official opening. The next day, he held a luncheon for the press and friends to promote the Long Island Motor Parkway and the new inn. The *New York Times* reported the event as follows: "His guests assembled at 1 o' clock at the Hotel Astor, where automobiles were waiting to carry them over the 40-mile course which motorists like so well because they can drive 'without fear of police or pedestrians.'" (Courtesy of the Suffolk County Vanderbilt Museum.)

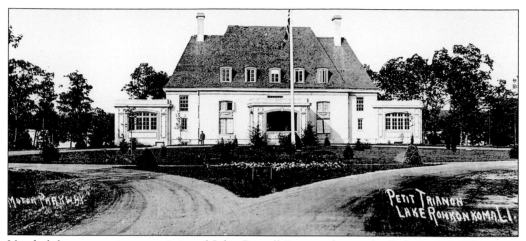

Vanderbilt once again commissioned John Russell Pope to design the Parkway Inn. The name was later changed to a more elegant sounding Petit Trianon Inn, after one of the smaller buildings on the grounds of Versailles Palace near Paris. The inn was located at the end of the eastern terminus of the parkway.

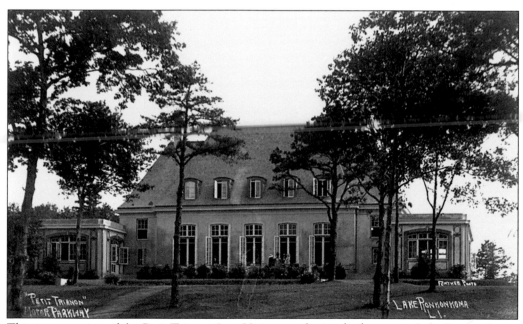

This is a rear view of the Petit Trianon Inn. Visitors to the inn had access to Lake Ronkonkoma for bathing, boating, and fishing.

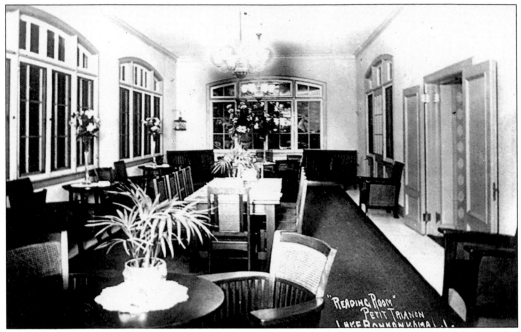

This postcard view shows the lounge area in the south wing of the inn. The interior of the inn also featured a large reception room suitable for weddings, balls, and special events. Accommodations for spending a night or weekend were available in the 30 bedrooms on the second floor.

Seen here is a typical newspaper advertisement promoting the Petit Trianon Inn as the ideal motor resort. (Courtesy of the Suffolk County Vanderbilt Museum.)

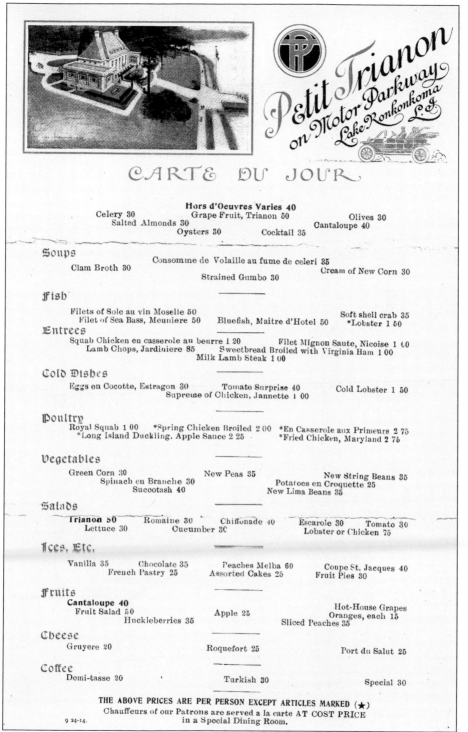

Petit Trianon
on Motor Parkway
Lake Ronkonkoma L.I.

CARTE DU JOUR

Hors d'Oeuvres Varies 40

Celery 30 Grape Fruit, Trianon 50 Olives 30
Salted Almonds 30 Cantaloupe 40
Oysters 30 Cocktail 35

Soups
Clam Broth 30 Consomme de Volaille au fume de celeri 35 Cream of New Corn 30
Strained Gumbo 30

Fish
Filets of Sole au vin Moselle 50 Soft shell crab 35
Filet of Sea Bass, Meuniere 50 Bluefish, Maitre d'Hotel 50 *Lobster 1 50

Entrees
Squab Chicken en casserole au beurre 1 20 Filet Mignon Saute, Nicoise 1 40
Lamb Chops, Jardiniere 85 Sweetbread Broiled with Virginia Ham 1 00
Milk Lamb Steak 1 00

Cold Dishes
Eggs en Cocotte, Estragon 30 Tomato Surprise 40 Cold Lobster 1 50
Supreme of Chicken, Jannette 1 00

Poultry
Royal Squab 1 00 *Spring Chicken Broiled 2 00 *En Casserole aux Primeurs 2 75
*Long Island Duckling. Apple Sauce 2 25 *Fried Chicken, Maryland 2 75

Vegetables
Green Corn 30 New Peas 35 New String Beans 35
Spinach en Branche 30 Potatoes en Croquette 25
Succotash 40 New Lima Beans 35

Salads
Trianon 50 Romaine 30 Chiffonade 40 Escarole 30 Tomato 30
Lettuce 30 Cucumber 30 Lobster or Chicken 75

Ices, Etc.
Vanilla 35 Chocolate 35 Peaches Melba 60 Coupe St. Jacques 40
French Pastry 25 Assorted Cakes 25 Fruit Pies 30

Fruits
Cantaloupe 40
Fruit Salad 50 Hot-House Grapes
Huckleberries 35 Apple 25 Oranges, each 15
Sliced Peaches 35

Cheese
Gruyere 20 Roquefort 25 Port du Salut 25

Coffee
Demi-tasse 20 Turkish 30 Special 30

THE ABOVE PRICES ARE PER PERSON EXCEPT ARTICLES MARKED (★)
Chauffeurs of our Patrons are served a la carte AT COST PRICE
in a Special Dining Room.

9 24-14.

The Long Island Motor Parkway contracted the management of the inn to the Hotel Astor of New York City. The 1911 menu provided an extensive selection of food as expected by the high-end clientele of the inn. (Courtesy of the Suffolk County Vanderbilt Museum.)

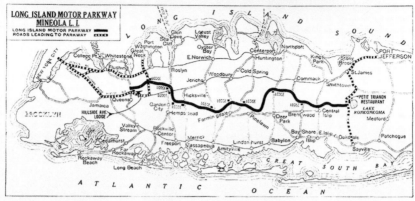
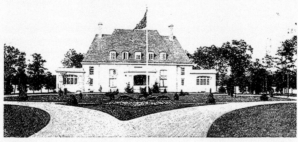
A seasonal operation, the Petit Trianon Inn would open in April or May every year and close at the end of October. With many parties held for Long Island's elite motoring set, the inn continued under Long Island Motor Parkway ownership until 1926. The inn later became a club and restaurant under various owners. On January 11, 1958, the building caught on fire during a snowy night. About 100 firemen from the Lakeland and Ronkonkoma fire departments trudged through 14 inches of snow to reach the inn, which had been unoccupied for years. After five hours of battling the blaze, the landmark building had been almost totally destroyed. The cause of the fire was never determined. (Courtesy of the Suffolk County Vanderbilt Museum.)

Nine

COLLECTIBLES
AND VANDERBILIA

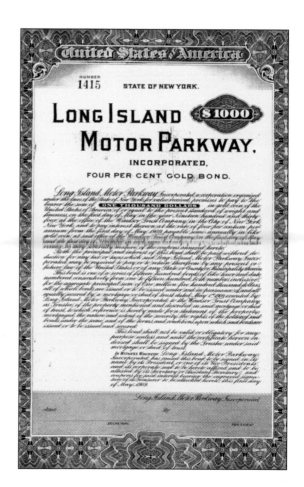

Collectibles and memorabilia from the Long Island Motor Parkway and the Vanderbilt Cup Races are highly sought after. They can be occasionally found in auctions, flea markets, and on the Internet. This is a $1,000 bond for the Long Island Motor Parkway paying 4 percent.

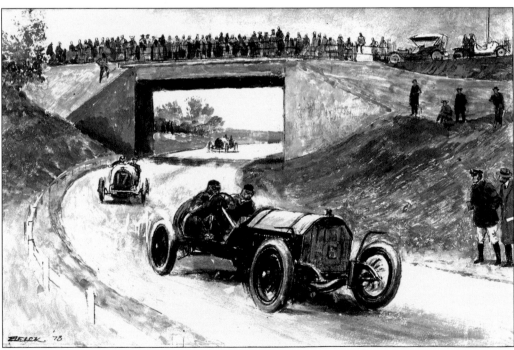

The rarest items associated with the Vanderbilt Cup Races are the 22 oval 13-inch-by-18-inch bronze plaques produced by Tiffany and Company from 1904 to 1916. The race sponsors produced two plaques for each race that were presented to the winning driver and manufacturer. This 13-pound plaque was awarded to George Robertson for winning the 1908 race.

CHALLENGE CUP
PRESENTED BY
W. K. VANDERBILT, JR.
TO THE
AMERICAN AUTOMOBILE ASSOCIATION
under deed of gift to be raced for yearly
by cars under 1200 Kilos

FOURTH RACE IN AMERICA
OCTOBER 24th 1908
Won by Locomobile Car
120 H.P. Driven by George Robertson
Time 4 Hours 48 Seconds
Distance 258.6 Miles

Peter Helck (1893–1988), rightly regarded as one of America's foremost automotive artists, painted many scenes of the Vanderbilt Cup races. In this painting, Helck has accurately depicted the winning No. 18 ALCO, driven by Harry Grant during the 1910 race. The scene was just east of the Stewart Avenue Bridge in East Meadow.

In celebration of its victory in the 1908 Vanderbilt Cup Race, Locomobile offered miniature versions of the silver cup, a radiator mascot for $2.25 and a version without the radiator cap for $1.50. Locomobile also provided special sterling silver versions of the cup to attendees of a November 9, 1908 victory banquet in Bridgeport, Connecticut. (Courtesy of Walter McCarthy.)

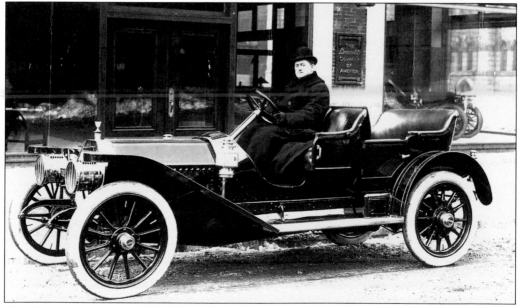

This Locomobile has the Vanderbilt Cup radiator mascot proudly displayed on its hood.

The five-inch square license plate issued by the Long Island Motor Parkway on an annual basis has always been popular with parkway enthusiasts, license plate collectors, and those with an interest in Long Island history. The plates were issued to purchasers of the season ticket, which permitted the motorist unlimited use of the parkway for a calendar year. During the 1920s, the Long Island Motor Parkway would supply two No. 25 plates free every year to the National Highway Association, which was formed for the betterment of highways.

This is the only known image of a car with its issued parkway plate in place. The plates were mounted on the front of the automobile and served as a forerunner of today's E-Z Pass.

Starting in 1922, the plate with the number 1 was issued to Joseph P. Grier. He would have exclusive use of this number until the Long Island Motor Parkway closed.

GOOD FOR THE DAY, WITH PRIVILEGE TO LEAVE AND RETURN

Date **JUN - 8 '24**　　War Tax 10 Cents
　　　　　　　　　　　　　　　　Price, $1.00

This Ticket entitles the holder to entrance with one AUTOMOBILE upon the

LONG ISLAND MOTOR PARKWAY, INC.

on the date stamped above, subject to the conditions on the back of this ticket. Not transferable and must be shown upon request to any representative of the Parkway Company or at the Lodge Gates of the Company.

Automobiles when stopping must clear pavement with all wheels.
Do not stop or park autos on top or under bridges, or on approaches to bridges or on curves.
The making of fires through the wooded section is prohibited.
Picnic parties please dispose of refuse and papers before leaving.

A.J. Kienzle

General Manager

Nº　369

RONKONKOMA LODGE　　　**Speed Limit 40 miles per hour**

Motorists paying the daily toll fee were issued a toll receipt, which bore the name of the lodge entrance used to access the parkway. The receipt was surrendered when exiting. This system discouraged motorists from entering the parkway through unauthorized locations attempting to avoid paying the toll fee.

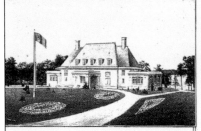

Open from May to October—

"Petit Trianon" Inn and Restaurant

END OF MOTOR PARKWAY ON LAKE RONKONKOMA
CONDUCTED UNDER THE MANAGEMENT OF ARTHUR H. MYERS

55 miles from New York Telephone Ronkonkoma 30

HOW TO REACH MOTOR PARKWAY
FROM NEW YORK AND BROOKLYN

Route No. 1—via Jamaica—Queensboro Bridge to Long Island City, follow Queens Boulevard to Hillside Ave., turn *left* at end of Hillside Ave., (near green houses) turn *left* as indicated by large sign, to entrance ¼ mile distant.

Route No. 2—via Flushing—Queensboro Bridge to Long Island City, follow Jackson Ave. to Broadway, Flushing, continue on Broadway to Bay Side, turn right at Bell Ave., (Police Traffic Booth on corner) to Rocky Hill Road, turn left as indicated by large sign to Motor Parkway Entrance.

Route No. 3—via Brooklyn—From Brooklyn Bridge or Manhattan Bridge or Coney Island, to Eastern Parkway to Bushwick Ave., to Jamaica Ave., to Hillside Ave., at end of Hillside Ave., turn left as indicated by large sign to entrance ¼ mile distant.

NASSAU GARAGE

JERICHO TURNPIKE MINEOLA, L. I.
"Twenty Four Hour Service"
Phone 1224 Garden City

LAKE RONKONKOMA GARAGE

Sumner Newton, Eight years in Locomobile Factory
Day and Night Service
Phone 13 Ronkonkoma

Long Island Motor Parkway

Private right-of-way built exclusively for pleasure automobiles at a cost to date of over $3,000,000, from which there is easy access to all points on Long Island.

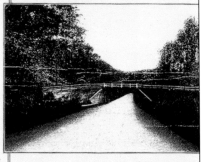

Scene along the Motor Parkway

A typical section of the Parkway with its 45 miles of paved right-of-way, showing one of the 55 highway and railway grade crossings eliminated.

Admission
Including War Tax

Pleasure Motor Cars, daily tickets, good for the day, with privilege to leave and return - - - $1.10

Car and party, season tickets, January to December $55.00

Car and Party, season tickets, July to December - $33.00

Speed limit 40 miles per hour

Also highly collectible items are Long Island Motor Parkway brochures. They were issued on an irregular basis, usually in conjunction with a new phase of the parkway. This 1926 brochure notified the motorists of the opening of the most westerly entrance at Black Stump Road at Fresh Meadows in Queens. Today the road is known as Seventy-third Avenue.

Parkway paychecks, made of brass and one and a half inches in diameter, were issued to the Long Island Motor Parkway construction workers. The paychecks were used instead of time cards.

Ten

THEN AND NOW

The crushing impact of the Depression coupled with the ever-expanding free New York State parkway system effectively sealed the fate of the narrow, winding parkway. Several innovative proposals were made for right-of-way, including a monorail rapid transit system proposed by the Queens Chamber of Commerce in 1935. However, William K. Vanderbilt Jr. never seriously considered the project due to the absence of financial guarantees. The most famous suspended monorail of this era was Schwebebahn, or floating railway, of Wuppertal, Germany, which began service in 1901 and is still in use today.

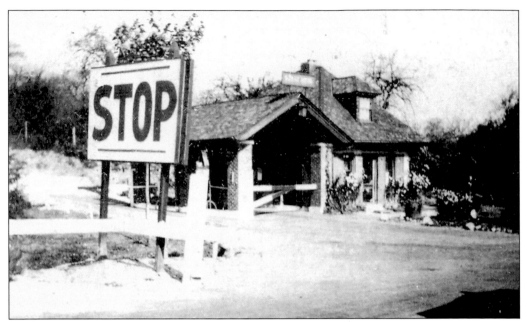

By 1910, the western terminus of the Long Island Motor Parkway was extended to Lakeville Road at Lake Success. The Great Neck Lodge, designed by John Russell Pope, was located on the north side of the parkway east of Lakeville Road. The lodge was located across the street from William K. Vanderbilt Jr.'s estate, Deepdale. (Courtesy of the Suffolk County Vanderbilt Museum.)

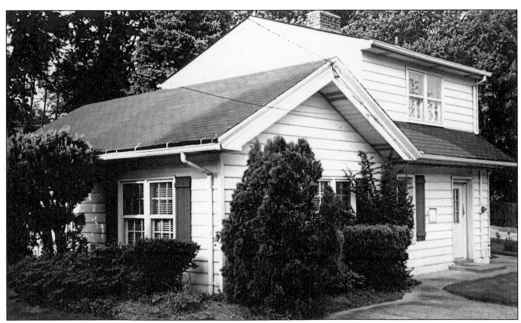

After the parkway closed in 1938, the Great Neck Lodge was converted into a home, as seen in this 1960s image. The building has survived into the 21st century and is still at its original location. While it was been extensively modified, the original overall configuration is still easily identifiable. (Courtesy of Dale Welsch.)

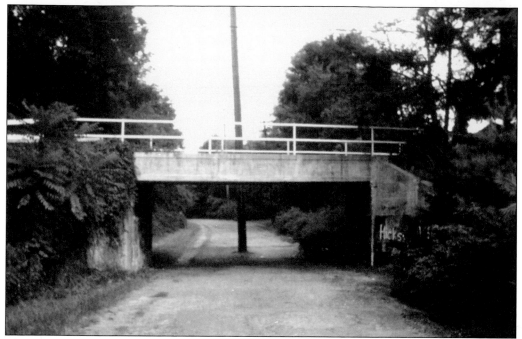

The Old Courthouse Road Bridge over the Long Island Motor Parkway is seen in 1972 looking east. Erected in 1910, the location is approximately 1,000 feet east of New Hyde Park Road in the Manhasset Hills section of Nassau County. This bridge is the only existing parkway bridge in Nassau County. This bridge is one of only two existing Motor Parkway bridges still standing in Nassau County. (Courtesy of Margaret and George Vitale from slides created by Lester Cutting.)

This 2008 image was taken from atop the Old Courthouse Road Bridge, looking west toward New Hyde Park Road. The poles down the middle of the right-of-way belong to the local utility company that has taken over this portion of the parkway for electrical transmission lines.

Seen here is a 1972 image of the parkway looking west toward Willis Avenue in Williston Park. Note the three-foot concrete extensions on both sides of the road. (Courtesy of Margaret and George Vitale from slides created by Lester Cutting.)

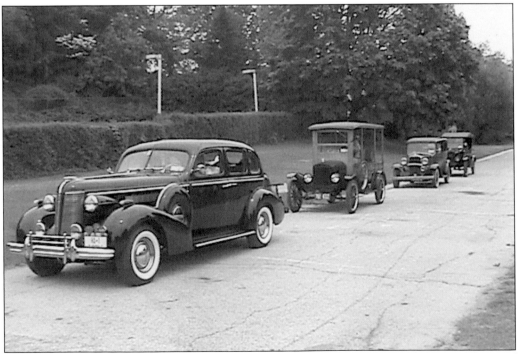

On May 18, 2003, the Village of Williston Park held a ceremony recognizing its portion of the Motor Parkway. Shown here are some of the vintage automobiles participating in the celebration.

The long abandoned Long Island Motor Parkway right-of-way is shown in the 1950s going under Jericho Turnpike in Mineola. The view is from the south side of the bridge looking north and was taken from the location of today's Donna Lane and Rudolf Road. (Courtesy of the Henry Ford.)

This is the same view as above in 2008. Note the building on the left and the tower on the right side, present in both images. In the 1960s, Jericho Turnpike was widened and the bridge was taken down. At that time, the parkway right-of-way was filled in and the site regraded to conform to the surrounding area.

This is the Mineola Lodge building in 2008. While it has been extensively enlarged, the original portion of the lodge is clearly observable on the left side. The porte cochere actually survived into the 1960s. The building is now a residence located on Rudolf Road.

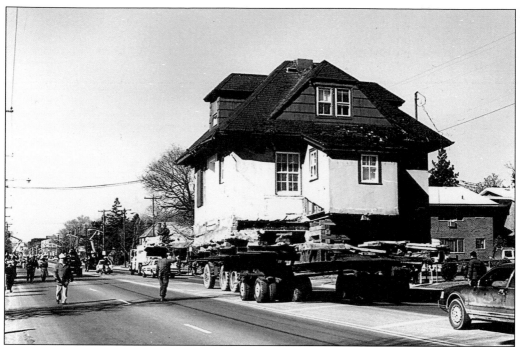

The Garden City Lodge was moved to a new location in 1989. By sheer coincidence, this photograph, looking west, was taken at the exact location where the Long Island Motor Parkway went underneath Old Country Road, at the Garden City–Mineola line. (Courtesy of Dale Welsch.)

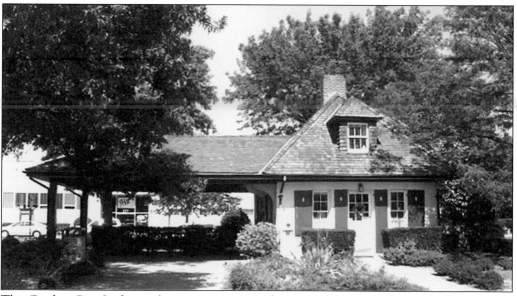

The Garden City Lodge is shown at its current location on Seventh Street in Garden City. Restored from 1989 to 1990, the lodge is the current home of the Garden City Chamber of Commerce, which maintains a small museum of parkway images and related memorabilia.

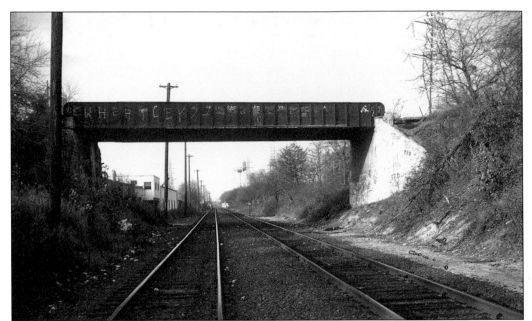

This is the parkway bridge over the Oyster Bay line of the Long Island Rail Road as seen in 1972 looking north. Erected in 1909, it connected the communities of Williston Park and East Williston. Long Island Motor Parkway bridges over roads were typically built with concrete. Those bridges built over railroad tracks were required to be of steel construction. The bridge remained in place until 1989, when it was taken down due to safety concerns, 90 years after it was erected. (Courtesy of Margaret and George Vitale from slides created by Lester Cutting.)

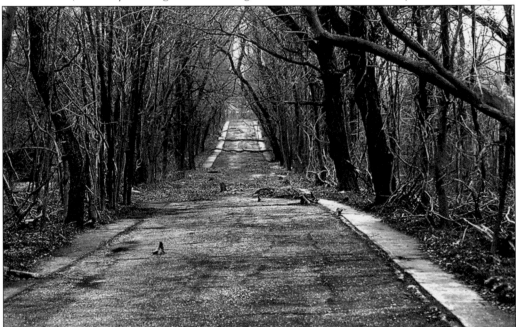

Seen here is a 2007 view of the Long Island Motor Parkway in East Williston looking east after the railroad bridge. This section of the parkway when constructed was only 16 feet wide. Three-foot-wide concrete extensions, the lighter areas, were added in the early 1930s.

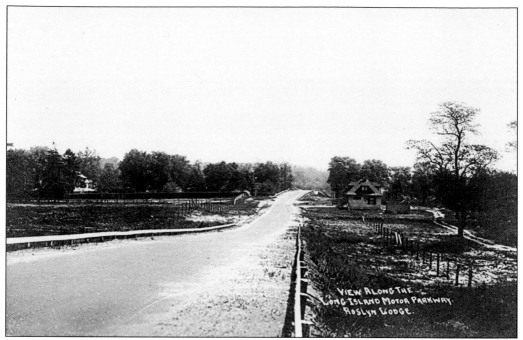

This image of the parkway through East Williston in 1928 is looking east from the Oyster Bay line of the Long Island Rail Road. On the right is the Roslyn Lodge, erected in 1910. The house on the left was the home of Alex Campbell, who sold the land to the parkway for the right-of-way through the area. As a condition of the sale, he had his own entrance to the Long Island Motor Parkway. The bridge over Roslyn Road can be seen in the distance. (Courtesy of the Suffolk County Vanderbilt Museum.)

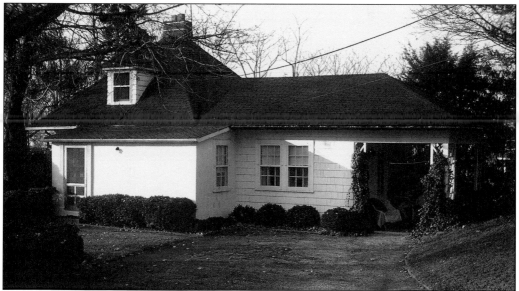

This is the Roslyn Lodge as it appeared in 1972. When the parkway closed in 1938, the lodge was purchased by John and Hilda Siisteri. They expanded the lodge, enclosing part of the double-width porte cochere. (Courtesy of Margaret and George Vitale from slides created by Lester Cutting.)

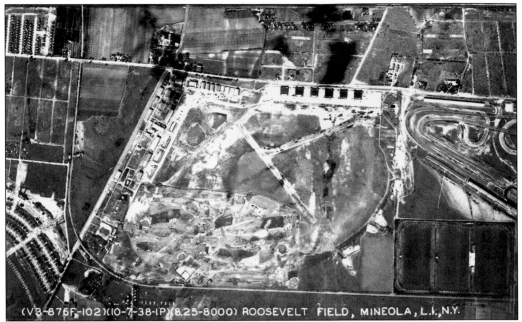

(V3-876F-102)(10-7-38-1P)(8.25-8000) ROOSEVELT FIELD, MINEOLA, L.I.,N.Y.

This spectacular aerial view of Roosevelt Field was taken on October 10, 1938. The Long Island Motor Parkway, which closed six months earlier, can be seen going around the airfield. From north to south and to the left of the airfield, the parkway goes over the Long Island Rail Road and under Old Country Road. At bottom of the image, the parkway headed east by crossing over Clinton Road. The original Old Westbury Golf Course adjoining the parkway can be seen at the bottom of the image.

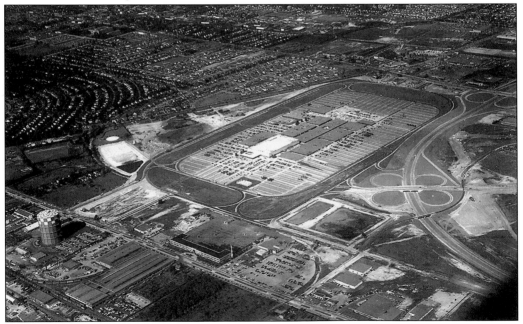

This is a similar view of this area as seen in 1955. The airfield has been replaced by one of Long Island's first and largest shopping centers. The Long Island Motor Parkway right-of-way was still easy to identify and served as the south service road for the Roosevelt Field Shopping Mall.

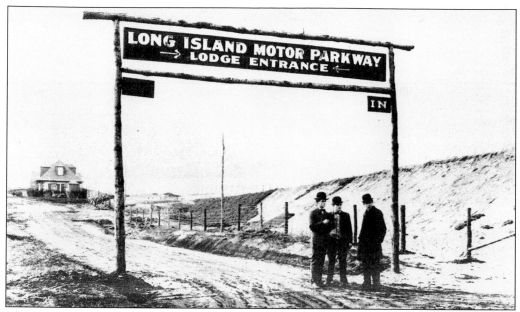

The entrance/exit ramp to the Meadow Brook Lodge was located on the south side of the Long Island Motor Parkway and west of Merrick Avenue in East Meadow. This 1910 image showed the lodge in the distance and the beginning of the parkway bridge over Merrick Avenue to the right of the three men.

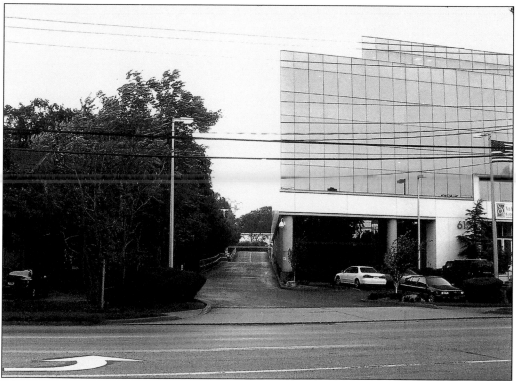

This is the same approach ramp as seen in 2008. Today it leads to a parking lot for the office building on the right. On the left is a tennis court complex.

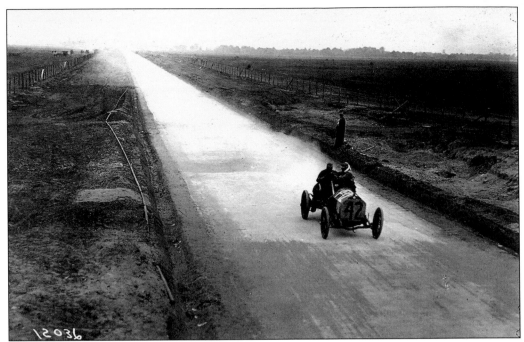

Herb Lytle is driving his No. P42 Isotta during a practice run for the 1908 Long Island Motor Parkway Sweepstakes. The photograph was taken from the Carman Avenue Bridge in East Meadow looking west with a dramatic view of the Hempstead Plains. (Courtesy of the Suffolk County Vanderbilt Museum.)

Here is the same East Meadow view in 2008. Eisenhower Park is to the left of the road. A strip of the Long Island Motor Parkway right-of-way on the right still remains undeveloped..

A 1947 aerial view looking east showed the location of the Long Island Motor Parkway from Wantagh Parkway (bottom of image) to the Jerusalem Avenue Bridge. The land south of the parkway was dedicated to farming before being developed for the homes of Levittown. The clubhouse and hangars of the Long Island Aviation Club, one of the first private country club airfields in the United States, can be seen abutting the north side of the parkway on the top left section of the image. (Courtesy of the Collection of the New-York Historical Society.)

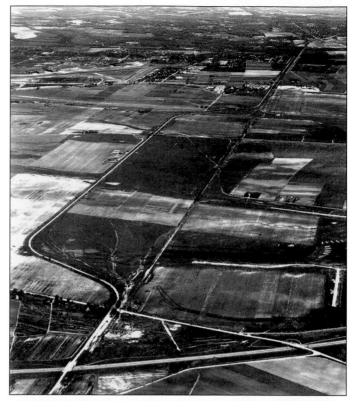

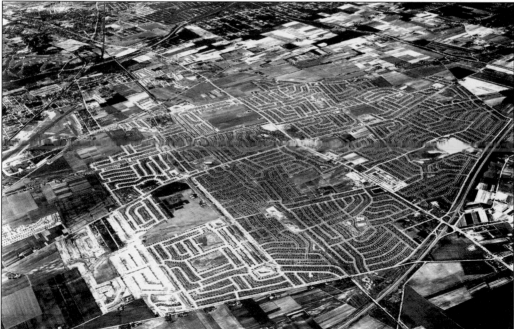

This same area in 1950 showed many of the 17,447 homes built in Levittown and its surrounding neighborhoods. No part of the Long Island Motor Parkway's right-of-way in this area was integrated into the local road system. (Courtesy of the Collection of the New-York Historical Society.)

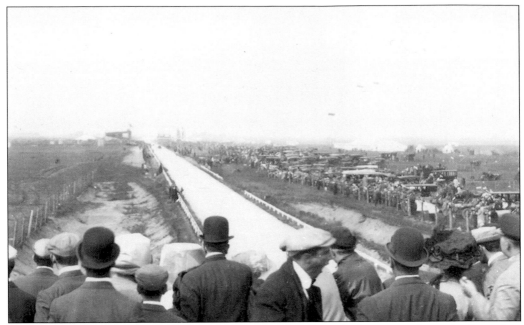

Seen here are spectators at the 1910 Vanderbilt Cup Race looking west from the Jerusalem Avenue Bridge. Note the grandstand in the distance on the south side of the parkway. (Courtesy of the National Automotive History Collection, Detroit Public Library.)

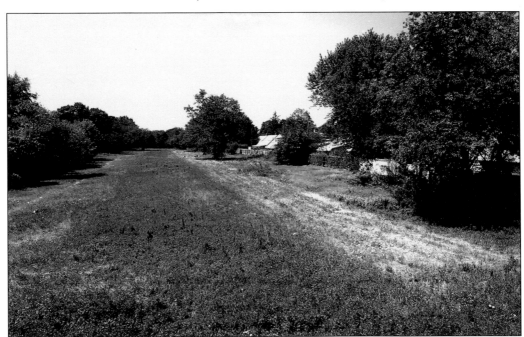

The Long Island Motor Parkway right-of-way in Levittown in 2005 was photographed looking west from Crocus Lane. The parkway's roadbed can be seen as the light area on the right side of this image. The 5,000-seat grandstand built for the 1908 to 1910 Vanderbilt Cup Races was located on the far left. Although completely surrounded by Cape Cod–style homes, this half-mile section of the parkway in Levittown managed to escape development.

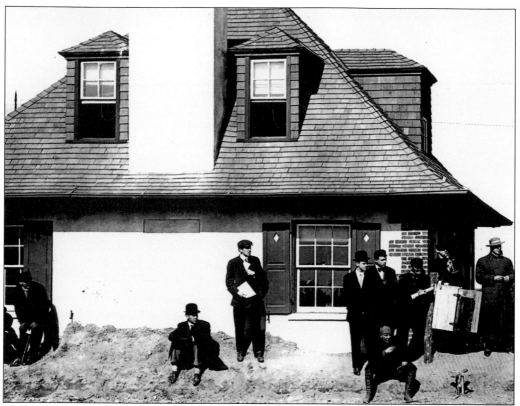

A close-up of the Massapequa Lodge was taken during the 1909 Vanderbilt Cup Race. (Courtesy of the National Automotive History Collection, Detroit Public Library.)

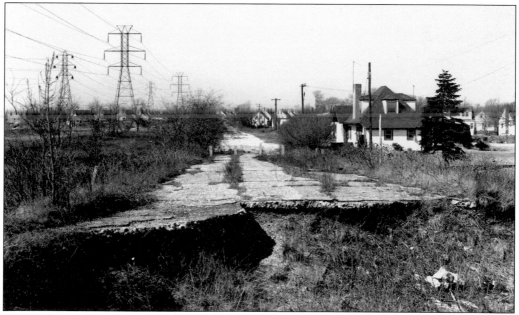

This is the same location as seen in 1959. The lodge was demolished in the early 1960s, and the site became part of a garden apartment complex. (Courtesy of Ron Ridolph.)

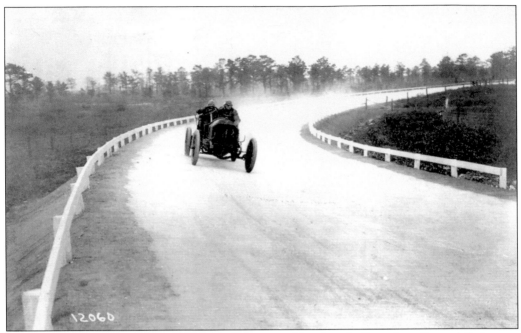

Frank Lescault is driving the No. P43 Simplex at a "Deadman's Curve" in Central Park, now Bethpage, during the 1908 Motor Parkway Sweepstakes. (Courtesy of the Suffolk County Vanderbilt Museum.)

Here is the same section as seen in 2008. The view is to the south as the banked Long Island Motor Parkway right-of- way curves to the right before reaching the utility tower heading toward North Hermann Avenue.

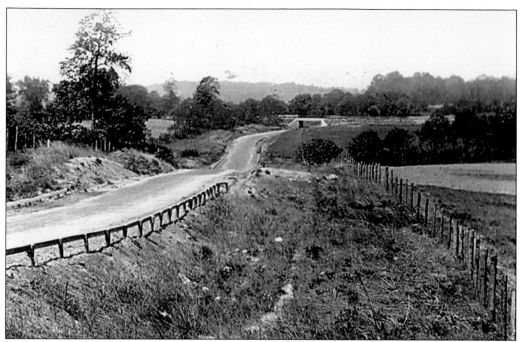

The Long Island Motor Parkway is shown in 1910 going through the north eastern section of today's Bethpage State Park. In the distance is the Botto Farmway Bridge over the parkway. Joseph Botto agreed to supply a 100-foot-wide strip of land through his holdings only if they would build a bridge over the right-of-way so he could have easy access to both sides of his now-divided farm. (Courtesy of the Suffolk County Vanderbilt Museum.)

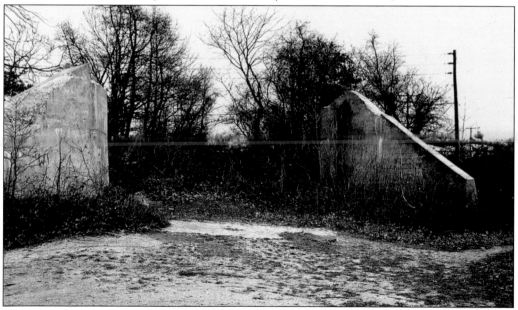

These are the remnants of the Botto Farmway Bridge in 1972. The embankments survived to that time only because the bridge was located in a wooded area of Bethpage State Park that was generally not used by the public. (Courtesy of Margaret and George Vitale from slides created by Lester Cutting.)

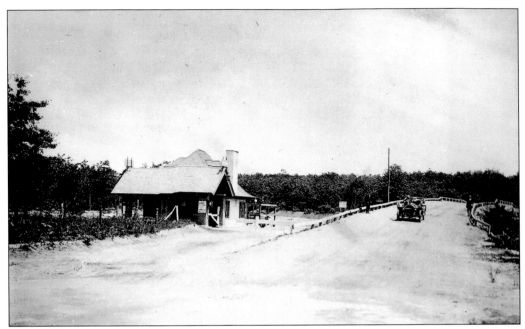

This is a view of the Bethpage Lodge as seen in 1910, looking east. The car has just crossed the Long Island Motor Parkway bridge over Round Swamp Road. (Courtesy of the Suffolk County Vanderbilt Museum.)

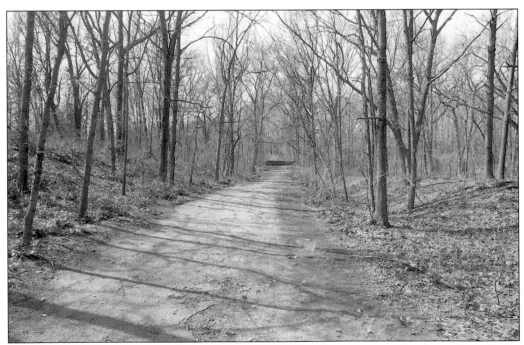

Seen here to the east of Round Swamp Road in 2007 is the parkway right-of-way through the Battle Row campgrounds in Old Bethpage. Since the campgrounds are part of the Nassau County park system, this well-preserved section is readily accessible to the public.

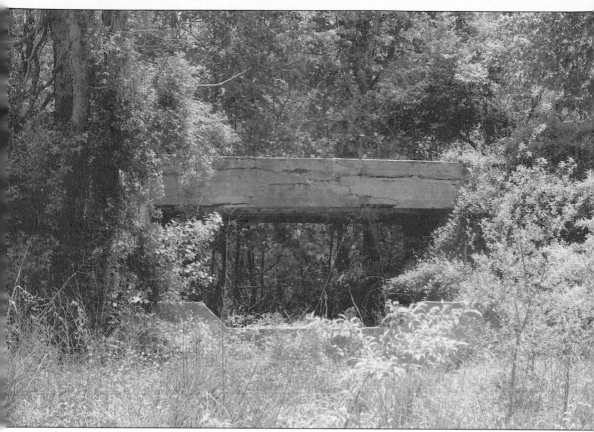

The abandoned Long Island Motor Parkway bridge in Old Bethpage Restoration Village is seen in 2006. The parkway ran through what today is the southern edge of the village, pretty much paralleling Bethpage Sweet Hollow Road. This particular bridge did not span a public road; officials described it as a farmway bridge.

Believe it or not, this is the Melville section of Long Island in 1972. The Long Island Motor Parkway passed through this area but has been replaced by sandpits. (Courtesy of Margaret and George Vitale from slides created by Lester Cutting.)

One pair of bridge embankments surviving to this day has been put to good use. This 1972 image is also in the sandpits west of Broad Hollow Road, north of Bethpage Spagnoli Road at Melville. The warning on the bridge states "slow down for curve." Almost 100 years after being constructed, the embankments are still strong enough to support a hopper capable of holding 30 tons of sand. (Courtesy of Margaret and George Vitale from slides created by Lester Cutting.)

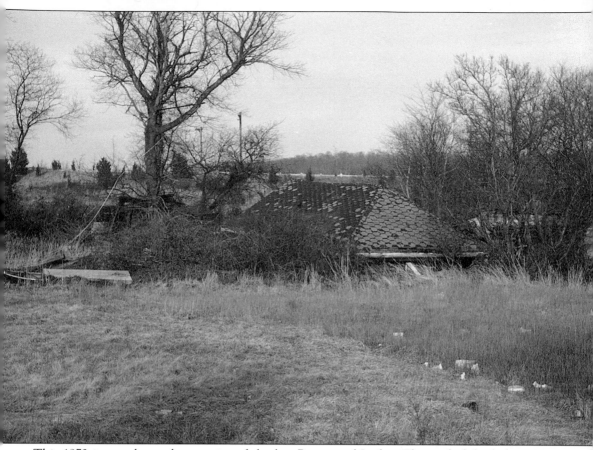

This 1972 image shows the remains of the last Brentwood Lodge. The roof of the lodge was left in a field near Commack Road. The lodge consisted of a ticket booth with extended roof sections on both sides. When the Long Island Motor Parkway closed in 1938, the structure was purchased by local resident Joseph Carll. He moved it to an adjacent parcel piece of land where he removed the ticket booth and left the rest of the lodge in the field. The remains survived until a shopping center was put up on the site in the 1980s. (Courtesy of Margaret and George Vitale from slides created by Lester Cutting.)

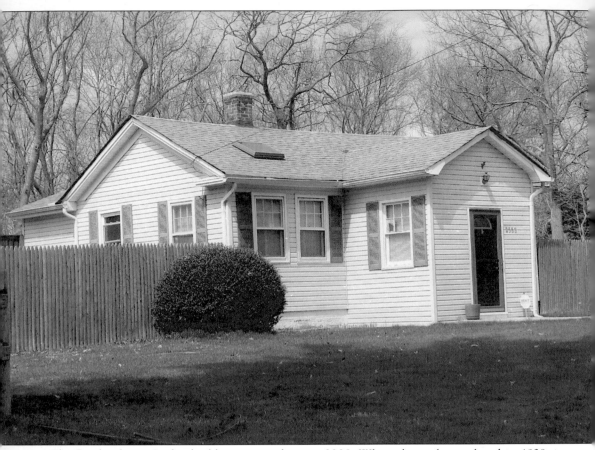

The Ronkonkoma Lodge building is seen here in 2008. When the parkway closed in 1938, it was purchased by the resident lodge keeper, Eric Ericson. He moved it, minus the porte cochere, off the 100-foot-wide right-of-way onto an adjacent piece of property. It still sits adjacent to the parkway, easily recognizable, and serves as a home.

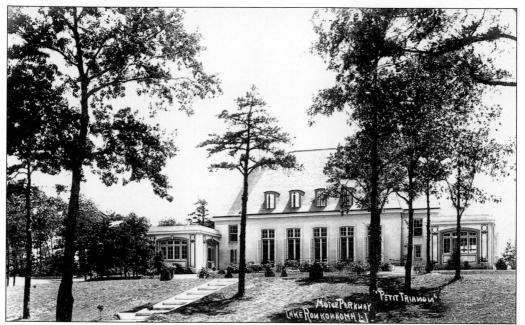

This is a 1911 postcard rear view of the Petit Trianon Inn taken from the west shore of Lake Ronkonkoma. Built by John Russell Pope, it opened in 1911 with upscale accommodations for high society.

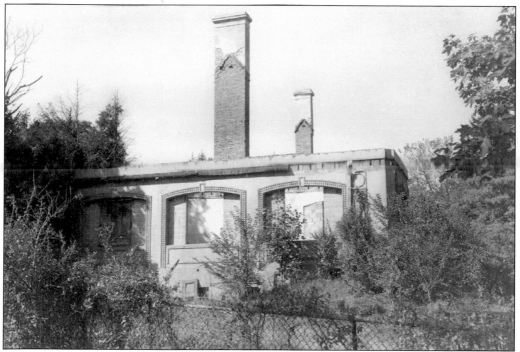

Sold off by the Long Island Motor Parkway in the late 1920s, the building survived until 1958, when it was destroyed by fire. The remnants of the inn are seen above as they appeared in 1960.

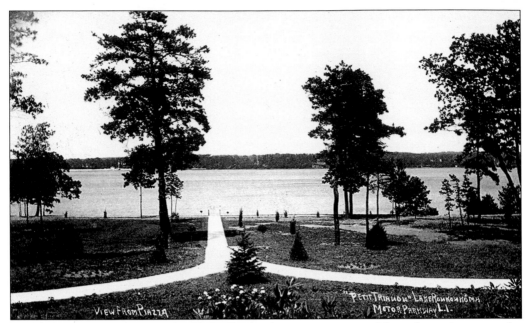

Seen here is a 1911 photograph of Lake Ronkonkoma as it appeared from the patio area at the rear of the Petit Trianon Inn. This bucolic scene was the setting for many festive occasions during the heady days of the inn's popularity.

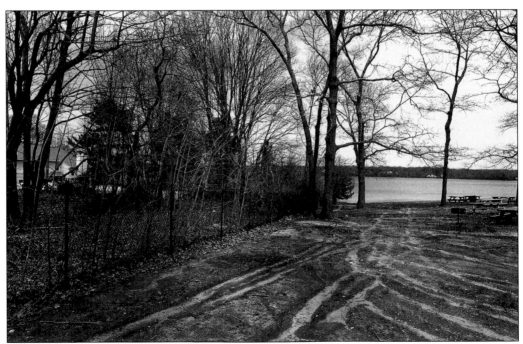

This is the same view as above as it appeared in 2008. The site of the inn is fenced in, undeveloped and adjacent to a public beach. Are the present owners of the property aware of its storied history?

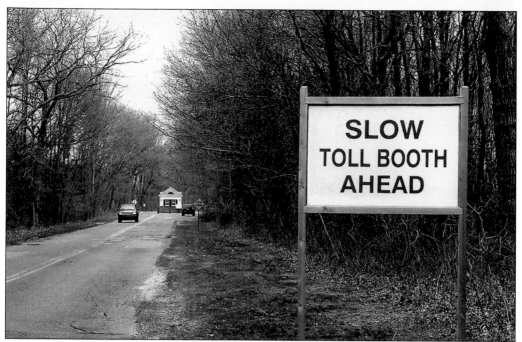

Enthusiasts will be pleasantly surprised to learn the Long Island Motor Parkway is back in business. This view, looking northeast, is in the polo field section of Bethpage State Park. After a 70-year hiatus, tolls are once again being collected on the site of the original parkway. Even though the parkway did not have a tollbooth in this area, park officials have unknowingly re-created a scene so familiar to motorists 100 years ago.

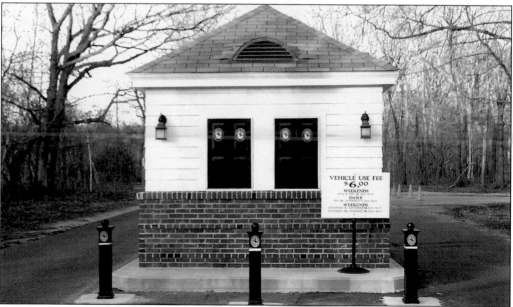

Here is a close-up view of the new Bethpage State Park tollbooth, shown in the distance in the above photograph. Sitting dead center in the middle of the actual Long Island Motor Parkway right-of-way, it eerily resembles the tollbooths used in the past, the only difference being the lack of a roof section on both sides of the booth. William K. Vanderbilt Jr. would be pleased.

www.arcadiapublishing.com

Discover books about the town where you grew up, the cities where your friends and families live, the town where your parents met, or even that retirement spot you've been dreaming about. Our Web site provides history lovers with exclusive deals, advanced notification about new titles, e-mail alerts of author events, and much more.

Find Your Place in History.